The Migrant Project

THE MIGRANT PROJECT

Contemporary California Farm Workers

RICK NAHMIAS

Foreword by Dolores Huerta

UNIVERSITY OF NEW MEXICO PRESS

ALBUQUERQUE

© 2008 by the University of New Mexico Press
Photographs © 2008 by Rick Nahmias
All rights reserved. Published 2008
Printed in Canada by Friesens, Inc.

14 13 12 11 10 09 08 1 2 3 4 5 6 7

Library of Congress Cataloging-in-Publication Data

The migrant project : contemporary California farm workers /
edited by Rick Nahmias ; photographs by Rick Nahmias ;
foreword by Dolores Huerta.
p. cm.
ISBN 978-0-8263-4407-6 (pbk. : alk. paper)
1. Migrant agricultural laborers—California—Pictorial works.
2. Agricultural laborers—California—Pictorial works.
I. Nahmias, Rick, 1965–
HD1527.C2M54 2008
331.5'4409794—dc22
2007033312

*The University of New Mexico Press gratefully acknowledges the generous contribution
of the Columbia Foundation for the publication of this book.*

Designed and typeset by Mina Yamashita
Composed in ITC Berkeley Oldstyle Std, a typeface designed by Frederic W. Goudy in 1938.
Printed on 80# Sterling Ultra Matte.

For my parents, Joyce and Nate

The reason why we want to remember an image varies:

because we simply "love it,"

or dislike it so intensely that it becomes compulsive,

or because it has made us realize something about ourselves,

or has brought about some slight change in us.

—Minor White,

"Photography Past/Forward:
Aperture at Fifty" (*Aperture 2005*)

CONTENTS

Foreword by Dolores Huerta / xi

Preface by Rick Nahmias / xiii

THE MIGRANT PROJECT:
Contemporary California Farm Workers

Exhibit Introduction / 1

Photographs / 5

ESSAYS AND ORAL HISTORIES

Alberto Juan Martinez: An Oral History—Anna Lisa Vargas / 89

California Farm Worker Defense: A Legal Aid Experience—José R. Padilla / 95

The Plight and Fight of Migrant Farm Workers in the United States—Kurt C. Organista, PhD / 103

Migrant Farm Workers and the Immigration Policy Controversy—Bruce Goldstein / 115

Lucrecia Catalina Camacho Santillán Gómez: An Oral History—Mily Treviño-Sauceda / 131

Acknowledgments / 137

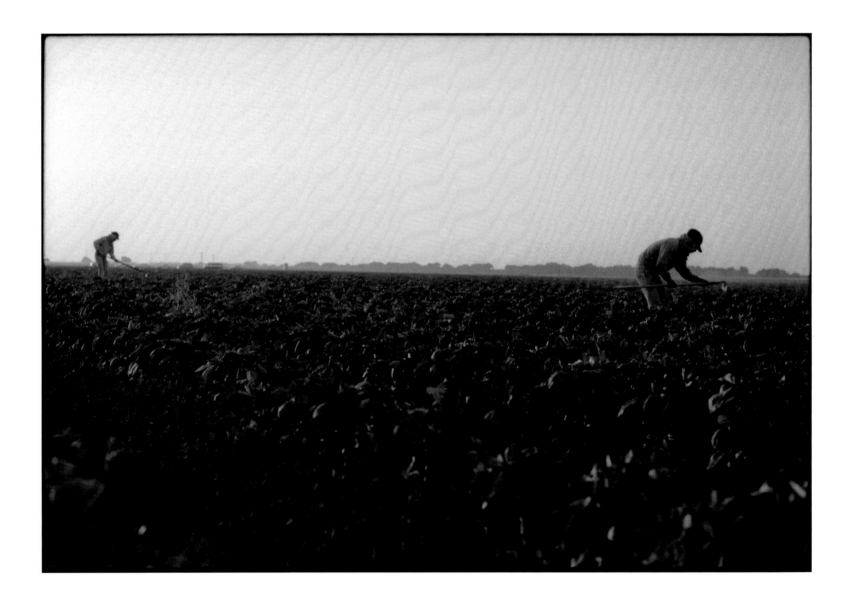

Foreword

Dolores Huerta

The images in this book bring us the lives of those who struggle to exist. While countless words in countless studies over decades bemoan the plight of those who toil in the fields to feed us, the conditions continue.

Rick Nahmias's pictures bring the workers into our lives in an unforgettable way. After viewing the many aspects of how farm workers have to live, the question that arises is why have we, in a civilized society, allowed these conditions to continue? There is no lack of monetary resources. Agribusiness is one of the most powerful, wealthy segments of society. Is it a question of racism, since most of these workers are workers of color? Or is it just benign neglect, out of sight, out of mind? These conditions do not have to exist.

Rick Nahmias reminds us that the journey to achieve social justice for those who feed us, which Cesar Chavez and myself started decades ago, has not yet been completed. The foundation was laid, a union model built, but we still have a long way to go.

The overwhelming majority of the states in our great United States of America to this day do not provide worker's compensation for farm workers. If a worker is injured at work, his medical bills are not covered nor is there a disability check. Although the work is seasonal, there is no unemployment insurance protection, forcing them to remain migrants, taking children out of school, and moving on to the next crop. The right to organize into a labor union is legal only in California. To gain the above rights in California cost the lives of five martyrs: Nan Freedman, Nagi Daifallah, Rufino Contreras, Juan de la Cruz, and Rene Lopez. They were all killed fighting for the basic human rights of farm workers. Workers cannot negotiate their wages. Many are undocumented and are further exploited because of their status. Although the farm workers' lives are full of hardship and poverty, Rick Nahmias's photos reflect the dignity of the farm worker.

Let us hope that this book will inspire those who read it to join with others so we can find and exercise the political will at the national level to bring farm workers' families into a just society in the twenty-first century.

Opposite: Workers weed pepper fields at dawn, Stockton

Preface

Rick Nahmias

This body of work represents one person's truth. Rather than attempt the impossible—summing up the collective experiences of the approximately 1.1 million farm workers working in California—this photo-documentary was conceived as, and remains, my window into a world few have the honor to witness, let alone record.[1] It does not attempt to, nor could it ever, tell their vast and multilayered story in anything resembling completeness. I hope, though, that the images and words within this book supply glimpses into how this community lives—how migrant farm workers are treated and mistreated, and how their life experiences keep them inextricably tied to the present, past, and future of America.

In the late winter of 2002, I set out to find answers to questions about the human cost of feeding America. These questions were born out of genuine curiosity compounded by a growing indignation toward how we as a nation are able to live our privileged lives without a deeper understanding or acknowledgment of what allows us to have such privilege. Though these seemingly simple questions were enough to set this project in motion, their answers prove to be incredibly complex.

The idea to explore the lives of contemporary migrant farm workers photographically had been percolating in me for years, but the months following September 11, 2001, proved to be a perfect incubator. September 11 is obviously important for the events that took place on that day, but of equal importance is the symbolic call for self-examination it gave to us as Americans. This was a call both personal and societal, a call Bill Moyers so perceptively framed as "a teachable moment."[2] Instead of traveling to Iraq or Afghanistan or turning a suspicious eye toward our newly defined "enemy," I felt an intrinsic need to look inward, to dig around in my own backyard for lessons.

Through every step of creating, exhibiting, and now publishing this work, I continue to be reminded of the advantages I enjoy solely based on the country, family, gender, and skin I had the luck to be born into. As a middle-class, white, American male I can pass countless visible and invisible hurdles that most if not all the people documented in The Migrant Project, would be felled by. Though I may have a slightly better understanding of these inequities now than before I began this work, they still leave me with more than a mild distaste for our society's two-tone structure of haves and have-nots, as well as an honest ambivalence for the work I do. Does being from the "haves" mean you should turn away from a calling to document the stories and lives of the "have-nots"

because doing so could be seen as further perpetuating the exploitation of the people upon whom your work focuses? Does not the fact one takes it upon his- or herself to tell *their* story, rather than having them tell it, reek of a paternalistic or cultural arrogance? These are legitimate questions to consider. Yielding to them, though, would mean that countless stories, which unify us around the human condition, stories that educate, inspire, and humanize us, would never be told.

Perhaps the tension created by being an outsider looking in, searching in earnest for the sameness that lies just below our otherness, is one of the strongest motivations behind my work documenting farm workers and myriad other marginalized communities.

<center>⚜</center>

I grew up in the strip-malled San Fernando Valley, a suburb of Los Angeles built upon one-time citrus and nut groves, and can count on one hand the number of times I thought about the farmland in the sense of it being the economic engine that drives California. Instead, the farmland I experienced was attached to the Agriculture Department of Pierce College, our local community college. It was home to a twenty-foot haystack that served as a late-night hangout for me and my disaffected high school friends. Even now, a slightly surreal memory of it lingers: philosophizing and partying late into the night on a Petri dish of a farm in the middle of L.A., soothed by its earthy, pungent smells and

those of the crops and small swatch of pastureland surrounding us, completely oblivious to their meaning on every other level.

Almost twenty years later, in January 2002, I found myself at the Culinary Institute of America, having signed on for a one-week intensive Introduction to the Professional Kitchen in the cavernous galleys of their Napa Valley campus. It was a gift to myself, a burgeoning foodie, who somehow felt a visceral tug toward the food industry. On a break from working as a researcher and writer for political columnist Arianna Huffington, the combination of food and politics somehow collided, leaving me to ruminate for much of the week about the source of the seemingly endless bounty that surrounded me, something my fellow students or teachers never once commented on during the time we were together.

These thoughts only intensified speeding home on Interstate 5, the spine of California's fertile Central Valley, past a hypnotic patchwork of farms. There, holding jagged lines in the dirt, were beat-up Cougars and dust-caked Plymouths, many serving as transportation, home, and nursery school, their brown-skinned owners stooped far off in the distance, working for wages I would soon learn rarely top ten thousand dollars a year.[3]

A few weeks later I told Arianna I was going to move on, and left with her best wishes. I did not know whether there was any true calling for me within the food world, but having put my creative work on the shelf for nearly a year, something inside was driving me to return to it, and in doing so to integrate it with the social justice causes increasingly drawing me in.

Around the time I was hanging around the haystack in high school, I had turned to photography as a form of artistic expression. Spending several hours a day holed up in the nearly deserted school darkroom, I produced images that expressed the world as I wanted to see it rather than how it was in reality. Since my grades barely passed muster, I turned to this work to secure a place in film school. But in the years following, I had only shown my photography intermittently in group shows, sold the infrequent print, and had no prospect of gallery representation. The difference now was, whereas I had been missing the impetus to conceive of or take on a large photographic project during that intervening decade, such a project (or at least the inspiration for one) was now looming before me. Only three things had any real clarity: I was growing angrier by the day with the state of where my nation was headed; something inside was saying I somehow *needed* to do this work; and what little money I had in the bank included nothing in the way of a budget to pull it off.

꧁꧂

As I moved into unfamiliar territory on almost every other level, I chose a familiar camera, my battered, trusty Nikon FE. I also chose to shoot black-and-white rather than color film. While color would impart the richness of the landscape and instantly contemporize the subject matter, there has always been a purity to the black-and-white frame that feels timeless and somehow less distracting.

Though I submerged myself in a variety of books, white papers, and websites about contemporary farm workers and current conditions in the fields, I purposely avoided studying images by other photographers past and present wherever possible, so that when I finally started shooting I would be going out with as fresh an eye as I could.

Eight weeks later, I was in the fields and farm worker camps of Oxnard, Fillmore, and Piru, about fifty miles north of Los Angeles. What would be my preferred mode of working soon developed: a couple of weeks before each trip to a region, I would get in touch with a local advocacy organization, such as California Rural Legal Assistance, Inc. (CRLA) or American Friends Service Committee (AFSC), tell them about my still-to-be-titled project, and ask whether one of their reps would be willing to help me break the ice with farm workers. The rest of the day was purposely kept free for happy (and unhappy) accidents and spontaneous discovery.

While solo, when I would come across a person or place of interest, I would have to rely on my minimal Spanish to get the ball rolling. In an attempt to beef up my four years of high school Spanish, I borrowed a set of language tapes early on and had one of the rare humorous moments of the project driving through a farm worker slum on an Indian reservation listening to formal Castilian dialogues between a diplomat and his hotel valet. Much more useful than the tapes was a book of my 8 x 10-inch work prints that were added to on each progressive trip. The awkward version of "show and tell" that ensued allowed me to get past my

self-conscious butchering of the language and helped boost my batting average with willing subjects from about .333 to .666 over the nine months.

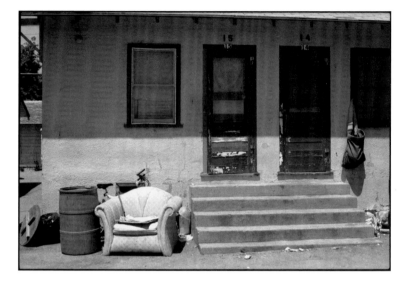

Migrant camp, Piru

5/3/02 Oxnard

DAY ONE: The camps in Piru and Oxnard were surreal: slum-like, crowded together structures in an oddly quiet and bucolic canyon-like setting. Small worlds completely unto themselves. It was mid-day when I arrived at the Piru camp, which, nearly empty, could have been a set from "The Grapes of Wrath," besides the fact there is pavement around the cabins instead of dirt. Even in the dead silence I sensed a distinct melancholy consuming the grounds. It was as if the patina of fifty years of energy exerted in the fields and the residual pain, had built up layer upon layer by multiple generations of workers, and was something you could rub off the little cabins like some sort of grime. The frayed orange sacks hanging forlornly outside several of the weathered clapboard structures held a sadness all their own. Though the sun could not have been shining brighter, the whole place felt completely tired and beaten down.[4]

Unless I was at a shape-up (the labor contractors' predawn ritual of hiring, then herding migrants onto their respective buses) or a crowded public space, I made a rule of asking subjects their permission before photographing them. In many cases I was granted it only if I agreed to not to use their names. I quickly learned anonymity is completely natural and accepted within the migrant world, something that for the undocumented worker (about half the population by most estimates) goes hand in hand with the near-constant fear of deportation.

It was all too easy to get caught up in the work, shooting six to eight hours each day in ninety or one hundred degree temperatures—a walk in the park compared to what the migrant workers endured daily. Since my sweat would simply evaporate in the heat, I would often forget to drink the copious amounts of water

needed, and more times than I would like to admit, I would find myself doubled over on the edge of a field by lunchtime. Even as I got better at dodging dehydration, what I could not get away from was the lingering depression that followed me home from the desolate locations and deplorable conditions—dirt lots, camps, or "homes" devoid of cooking and bathing facilities or basic sewage systems—to an apartment in, of all places, Beverly Hills. Spending days at a time in nothing short of third world America, then returning to the entertainment capital of the world, I spent considerable energy trying to make sense of how these two worlds could exist close to one another, yet be in such complete denial of each other.

The transition of traveling from one to the other became so jarring I began routing my return trips home through some urban decay (Echo Park or East L.A.) whenever possible to help ease back into the overwhelming affluence of West L.A. Ultimately friends and family learned to give me space to decompress for a good couple of days after I came home before getting in touch. It was time I would spend trying to understand the two worlds I was straddling. I made little peace with my own simmering anger at what I was seeing on the road and how it was utterly eclipsed in the public's mind by the political fear machine that was chugging along in high gear.

7/21/02 Lamont

This morning's breakfast at The Scotsman Restaurant

(intersection of Highways 184 & 58) was as American an experience as any so far. As I sat reading Steinbeck's "Harvest Gypsies" I heard two different conversations— one about the war, the other filled with hateful language aimed at immigrants. One of the participants was using an electric voice box, and grammar I thought you only heard in movies or read in Faulkner. His voice grew closer and I finally looked up to see an incredibly forlorn Anglo man in lopsided overalls that accentuated the droop of the right side of his face. As he approached, his eyes stared off, as if toward some part of his life that was no more—a lost farm, deceased wife . . . ? Who knows. He stopped beside me to pay his check at the register over which hung a massive paper banner bearing a slogan I have seen everywhere I seem to look out here (and which I've since taken to photographing): "God Bless America."[5]

⁕

After a day of shooting Santa Maria strawberry farms, a masters student at the University of California at Santa Barbara who was studying women's roles in immigrant families invited me to spend the night at the home of her parents, a pair of retired farm workers. They had generously offered me a room in the very modest single-family home they had bought over a decade earlier with funds accrued from the father's fieldwork, which began with his days as

a bracero. They had industriously carved off about a third of the house, and converted the garage as well, creating two units they rented to farm workers traveling through town for Santa Maria's mammoth strawberry harvest.

I was treated to my first authentic black *mole*, prepared by the matriarch. She was spending her retirement alongside her husband as he traveled daily to local fields, operating a small catering truck. What first came off as a sweet entrepreneurial spirit was quickly eclipsed by my realization of the cruel financial necessity of them *having* to spend this time selling farm workers their breakfasts and lunches. A lifetime of fieldwork, even with the under-the-radar rental income their ad hoc apartments generated, still left this couple without the means to make it through retirement. So, I asked myself, if these were the industrious and well-off set, what becomes of those who did not have their entrepreneurial spirit or good fortune?

After dinner, I drove to the center of town looking for farm workers in repose. I found none. I parked and continued on foot, soon finding a darkened section of boulevard lined with a long row of low-end motels, their parking lots packed with dirt-caked and decrepit cars (throughout this project this would be a telltale sign farm workers were near). Outside each room sat a tangle of metal strawberry harvesting carts. Beside the carts sat pair after pair of muddy shoes huddled tightly together, as if trying to stay warm in the moist, cool air before being forced to slog through yet another day of the peak harvest. Just inside, their exhausted owners were piled in similar formations on the beds and floors, wherever space allowed.

I had read a lot about how overcrowded housing was one of the top problems migrants faced. For decades, a persistent question has been: who can afford to build decent housing for a population present only a few months of the year? It is a dilemma with no easy solution, but seeing firsthand how those forced to bear the consequences of leaving the issue unsolved was beyond distressing.

I was drawn into a pile of shoes, each pair a worn and beaten story of its owner's journey. I made the rounds to three adjacent motels. It was only my flash (one of the few times I was forced to abandon my strong preference for using available light) that gave me away. I first earned curious stares, then glowers from the migrants who darted to their windows, pulling back the curtain far enough to reveal the eight or ten people sharing their two-person rooms, before they would shoo me away.

It was when I returned from another trip a few weeks later that a package containing *Let Us Now Praise Famous Men*, James Agee and Walker Evans's study of sharecroppers of the American south in the mid-1930s, was waiting on my doorstep. A sociology professor who had led me around the fields of Santa Maria had urged me to find a copy. Flipping through it, I came upon Walker Evans's image entitled "Migrant Shoe" for the first time. I felt a distinct and haunting instance of déjà vu. (I soon experienced this feeling even more strongly when I saw Evans's "Migrant Grave" from the same book laid beside the proof print of my image "Not Forgotten.")

Rather than feeling I was going over old ground, this confirmed that what I was doing had a vital, contemporary, albeit sad, link to the past. Though I was being turned down for grants on what seemed like a weekly basis, this synchronicity alone compelled me to continue.

The deeper I got into the project, the clearer I was about losing the fantasy of having a "neutral" or "objective" point of view. Simultaneously, I understood that wherever this work might eventually be shown, many more people would see it if I avoided injecting it with a specific agenda. The work prints, which now began wallpapering my office, were a powerful enough indictment of the current state of affairs on their own. There was no need to make things look any worse or dig for scandal—it was all right out there before me.

5/14/02 *Calexico*

The cruelest truth is that little things may change for these people, but the basis of their work never will. When one accepts the reality that strawberries are just too delicate to be picked by anything other than human hands, the only conclusion is that without fail, the lowest rung of society will somehow always be relegated to this sort of work.[6]

By early summer, about halfway through the eight trips I would take in total, I started to see the rough mosaic taking shape on my walls: farm workers at work, play, with family, dealing with workplace injury, scraping together housing and community. Only then did I begin to get a clearer vision of the multidimensional portrait that this work might provide. There was no question there was a long legacy of much greater and more in-depth work about farm workers, even exclusively California farm workers, as Richard Steven Street would later so poignantly and comprehensively explore in his books on the subject. What I had not seen was this community depicted in a range of circumstances much beyond stoop labor and protests, depictions that would invite a humanizing identification *by and with* middle-class Americans and which might result in making it harder to deny farm workers' existence and keep them in the shadows: images of migrant school pageants, grandparents with grandkids, home building, etc. I then came to posit that if my work had anything to possibly contribute to the large body of farm worker documentary work that went before me, it might be that—an element of "normalizing" the farm worker experience in a way so we could see the "us" in "them."

I started to see holes, things I was missing: recreation, retirement, women's issues, but I still avoided creating specific shot lists. I knew editing the work would be daunting, but I needed to stay in the moment with the shooting as it was happening and let it dictate the direction rather than have me do it. That said, keeping my antennae up for subjects of particular importance while simply trusting and remaining plugged into the spontaneity of what was unfolding in the work on a day-to-day basis ended up being one of my greatest challenges.

As things played out, I soon after interviewed and photographed a farm worker in Bakersfield battling AIDS: María, a woman who stuck to her commitment to meet with me even though earlier that day her Latina landlord, who had just learned of María's illness by snooping through her mail, had evicted her. Then just outside Cutler I ran across a family who played daily in the cool runoff of an irrigation ditch, not unlike people might use the pool at the local YMCA. In Biola, about forty minutes outside of Fresno, I would be smuggled onto a grape farm, which supplied Sun-Maid Raisin, where a trio of brothers and their father worked, living in a two-room shed with virtually no communication with the outside world until they paid off their Russian immigrant farm owner for their passage from Oaxaca.

The photographs I made were a record unto themselves, but there were many things I experienced in gathering them that left indelible impressions, impressions images or words will never be able to convey. In Brawley I was overwhelmed by the sweet, earthy smell of fertile soil melding with hundreds of sacks of sun-warmed just-picked onions; in Oceanside, it was hard to get away from the putrid odor of raw sewage stagnating just feet from the lean-tos most workers called home, overtaking their encampments and everything they owned. There were also numerous instances of humbling generosity where farm workers, literally living out of a few cardboard boxes, insisted on loading me down with armfuls of fresh grapes or strawberries to thank me for the work I was doing.

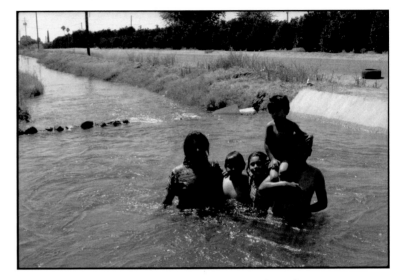

Family bathing in irrigation canal, Cutler

In terms of desperate conditions, shameful pecking orders, and dog-eat-dog modes of survival I witnessed, each trip seemed to eclipse the last. Though it was at times difficult to record the images and stories that clearly exposed rife exploitation occurring *within* the farm worker community (Mexican-American farm workers ripping off Mexican workers, who would turn around and exploit non-Spanish-speaking indigenous workers), it felt essential to leave political correctness aside and capture it all, trusting viewers to make their own decisions about what they were seeing.

Along with my camera, I brought my self and my past into the fields. Having nurtured a cinematic sense of storytelling, as a

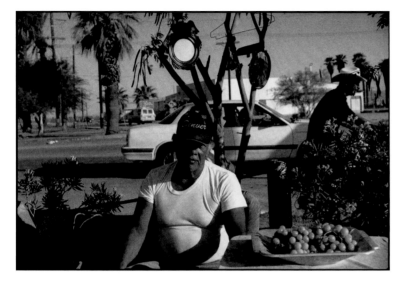

Toribio, a grape worker, offered fruit and a place at his table
at the end of a day of work, Mecca

screenwriter and filmmaker in the years leading up to this project, I had always found my preferred way of approaching any subject or story was to slice through its many layers, using the most human details to give the fullest picture. Creating The Migrant Project would be no exception. The best example of this is the scene I encountered in the tomato fields of Stockton.

Early one morning I had been taken by community worker Luis Magaña, of the Quaker group AFSC, into the tomato fields. Getting out of the car, I was instantly overwhelmed by both the smell of hot earth and tomato and the panorama of a literal army of men anxiously waiting along the edges of the ten-acre field for the signal that the morning dew had dried enough for them to begin work. This took longer than usual because of overcast conditions, causing a delay in work, which in turn would impact potential earnings for the day. Thus when the signal came in the form of a tooting car horn, the workers flooded in from all directions as if sprinting onto the field at the conclusion of the World Cup.

Men immediately dove to their knees and began crawling through the muck and thickets of tomato plants to fill a pair of pails with about twenty-five pounds each of green fruit as fast as possible. They would then dash to the nearby open-bed semitrailers, thrust their pails above their heads, and have the fruit emptied and replaced with a single brass token worth ninety-five cents.

After shooting the wide shots of the men crawling en masse, I needed to get closer. I climbed up on the trailers where the tomatoes were being emptied, and hovered over the shoulder of the woman pitching the tokens into the just-emptied pails (aside from her, not a single woman was anywhere in sight). I then photographed the men impatiently lined up in their mud-smeared layers at the truck beds. Wanting more detail to help define this incredible assembly line and its rich array of textures, I sought out a single individual. It quickly became clear that because of the late start, no one had the slightest interest in indulging me. Finally, I found a man hunched and sweating between two of the trailers, hurriedly finishing his breakfast of two greasy tacos that were balanced on his lap while he counted his morning's take—seven tokens. He looked up, his grimy cap soaked through with sweat.

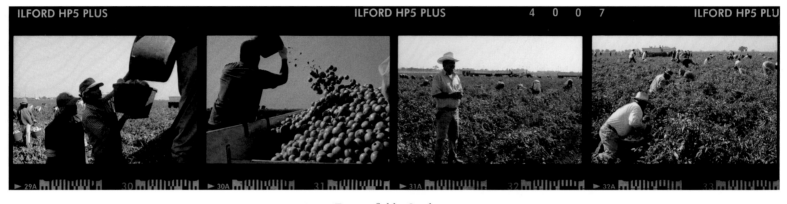

Tomato fields, Stockton

He held out his hand, providing the close-up that I hoped would complete the story.

❧

Knowing I wanted to include at least one trip to the border, I chose the Calexico/Mexicali port of entry over San Diego/Tijuana. This was the result of hearing of the unique shape-ups and guest-worker crossings that occur nightly and turn the deserted downtown area just blocks from the border into a crowded movable bazaar of humanity searching for any sort of employment possible.

After several e-mail exchanges, I arranged to meet Lupe Quintero, a veteran community worker for CRLA. In addition to her normal work schedule, a couple of times a week Lupe will pull a graveyard shift, where from about two to five in the early morning she pokes around the shape-ups downtown and scrutinizes labor contractors' treatment of farm workers, making sure they are supplying the regulation port-a-potties, clean drinking water, and other things required by law. We rendezvoused in downtown Calexico at one thirty in the morning, and as she guided me around, I shot the guest workers crossing at the actual port of entry, then continued on with them to the shape-ups. We then followed the buses out to the early morning work in the onion fields, getting a much truer sense of the full cycle of a migrant's day than I had experienced up to that point.

About seven hours later, I was satisfied. It had been a successful night and early morning of shooting, both in town and out in the fields, yet Lupe quietly insisted she had one more place I needed to see before we headed back in for the day. I fueled up on coffee, she on orange juice, and we traversed the Imperial Valley one more time.

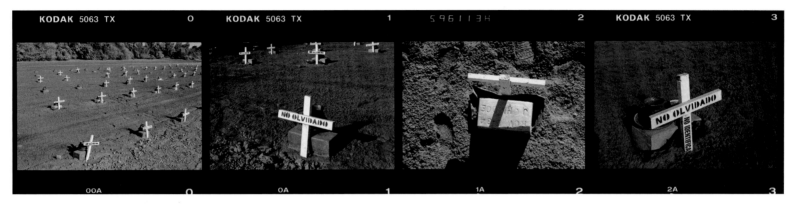

Potter's field, Holtville

At about ten thirty that morning, the temperature hovered around one hundred degrees as we entered Holtville, a quaint but rather nondescript industrial farm town. Lupe directed me to park alongside a small cemetery on the outskirts of town: manicured green plots with traditional polished granite headstones, several bouquets of flowers announcing recent visitors, nothing out of the ordinary. She then motioned me off to the side, and I followed her down the pristine gravel path onto a trail winding beyond the last of the cemetery's few trees and into a clearing.

There under the now baking sun, was maybe a half-acre of parched earth upon which lay row after row of little white crosses made of whitewashed garden stakes, all stenciled in black with the words "No Olvidado" (Not Forgotten). Each grave had an adobe brick identifying either Jane or John Doe and a small ceramic pitcher and saucer where offerings could be left. The gravity of the place was immense and palpable; the absolute silence and white-hot breeze lifting around us only amplified it. I slowly began shooting, watching out of the corner of my eye as Lupe went around to every grave, straightening crosses that had fallen over or wiping clean the tiny pitchers. She was determined that this potter's field retain whatever shred of dignity it held, carried by an intractable insistence that its occupants be treated and counted as human beings no matter how the community or nation around it felt.

We drove back to her office in El Centro in near silence. While I went on back to my hotel to try to catch up on sleep, she went on to work a full day.

5/14/02 Calexico
Shot the crossing on two hours of sleep last night . . . Once again I'm finding it hard to settle and get some decent rest.

Is it knowing they are still out there—the peak day sun topping 100 degrees and it's just barely noon, still harvesting onions, or just finishing up six hours straight of tossing melons? Conditions may have gotten better for a scant few —minimum wage here, a new temporary public housing project there—but what never changes, and never will is the back-breaking work they will do their whole life.

Starting with the 2 a.m. border crossings, and ending at the potters field, drove home the thanklessness of this life like nothing else has, or I believe, could have . . . Lupe's earnestness, dedication and consistent emotional attachment to these people—her people—is remarkable. As I was about to drop her back at her office, I asked her how she keeps from burning out. She simply replied, "How can I? Who else will be there to do this?"[7]

Though I cannot say I have a favorite image from this body of work, "Not Forgotten" holds the most meaning for me. Ironically, it does not include the face of a farm worker. Instead, it very plainly records an anonymous cross marking the grave of a migrant who either died here without anyone to claim her or had no money to have her remains sent home to Mexico. Or she may have been one of the approximately four hundred migrants who die annually while trying to cross the U.S.-Mexico border.[8]

❧

Each trip had its own personality, each location etching some different set of sights, smells, and emotions onto my film and into my memory. Most of these impressions were raw and unforgiving, but a handful were hopeful, like the Mexican rodeo, or *charreada*, outside Tracy. After failed attempts to find a charreada on past trips, I was to learn these spontaneously organized private gatherings of several hundred participants are purposely kept under the radar since they operate without permits, shun corporate advertising, and follow their own ethics when it comes to the humane treatment of animals. They had remained the elusive brass ring until the final day of my final trip, whereupon I was directed to one that would have been impossible to find if it were not for a game of telephone in broken Spanish with a pair of brothers on several static-filled cell phone conversations.

When I arrived, the Charreada Federation's president had to be summoned to get me and my camera past security. He proceeded to give me a grand tour through the cultural, sporting, and even culinary side of the heavily ritualized event from which our American rodeo directly descends. It was an extremely satisfying way to cap off the shooting of the main body of the project, not just because I had finally found what was starting to seem like a mythic event, but also because approximately one-third of those in the stands and competing came directly from farm worker backgrounds. Here were people who, otherwise mostly visible laboring in the fields or living in squalor, were in the very rare state of repose: enjoying family and simply having fun in a multigenerational setting. The

irony remained—even when recreating, they were only feet from the very fields and vineyards they would be returning to tend the very next day.

❧

Though seemingly simple in concept, editing is a difficult process. It is a house of cards requiring detachment from the emotion that first drove you to make an image, as well as a sense of being able to pull back far enough to see a larger story unfold and know what will help it be told with candor, humanity, and grace.

Once I had chosen the images, they needed to be ordered, not necessarily chronologically or geographically, but in a way that would draw the viewer in on a journey, providing a rhythm, and giving people a beginning and end point. Ultimately those bookends became the image "Bracero Rally," to give a sense of where the farm workers had come from, and ended with the hopefulness of "March for the Governor's Signature," depicting the fall 2002 United Farm Workers' March and an idea of where the farm workers were going. In between these more historical moments, viewers would, I hope, gain some insight into lesser known, yet equally important elements of farm worker life, while still being able to draw their own conclusions.

❧

In March 2006, and then on the decidedly symbolic May 1, 2006, millions of immigrants—documented and undocumented—took to the streets in cities and towns across America demanding reform of our country's immigration policy into something both fair and humane. Farm work is an often necessary first rung on the labor ladder for immigrants coming into the United States from Mexico and Central America. One might assume that the bulk of these throngs were campesinos fresh from the fields, having left their strawberry wagons or tomato pails behind as they ran to Los Angeles or Dallas or any other number of cities where protests took place, to be counted. Since these impressive shows of strength mostly took place in cosmopolitan centers, however, those who attended were predominantly urban and suburban Latinos and immigrants and their supporters.

This had less to do with desire than with the cruel economics that surround their livelihood. Strawberry season was about to peak in Santa Maria where nearly nine million trays of strawberries would have to be packed in a few short weeks. Missing a day of work, let alone for marches centered around a controversial "economic boycott," could easily result in losing one's place in the lucrative spring harvest. Still, in their world, where there are no paid vacations, and health insurance does not exist, scores of buses were booked by unions and nonprofits alike to transport farm workers from the hinterlands, making sure that those who wanted to have their voices heard in person were able to.

Broad, robust clouds filled the sky above a vibrant Wilshire Boulevard in Los Angeles that breezy May Day, sheltering the massive three-mile long crowd from the bright sun as hundreds of

thousands marched to take their place in the public's consciousness. I have experienced this sort of coming together very few times in my life—times when artificial boundaries spontaneously melt away and I am lucky enough to be swept up in a wave of humanity that forces me to abandon my "self."

Having traveled the country with The Migrant Project, I have seen farm workers enter libraries and museums, many for the first time in their lives, and well up upon encountering the first dignified depictions of their community they have ever seen. They are some of the noblest people on this planet, and I am humbled to have had the chance to act as a creative midwife of sorts in bringing even a few of their stories to the public. Through this whole experience, it has become my emphatic belief that beyond key policy reform, the raising and enforcement of our minimum wage, and other important legislation, first and foremost one thing must take place: an essential shift in the American psyche toward *compassionate inclusion* of farm workers as vital parts of our lives and our social and cultural fabric. Only then can we hope to see fundamental and lasting change in their lives.

Notes

1. M. Akhtar Khan, Philip Martin, and Phil Hardiman, "California's Farm Labor Markets: A Cross-sectional Analysis of Employment and Earnings in 1991, 1996, and 2001," in Labor Market Information Division, Employment Development Department of the State of California, Sacramento, 2003, 2–3, http://www.calmis.ca.gov/special reports/ag-emp-1991 to 2001.pdf (accessed June 2007).

2. Bill Moyers, "Which America Will It Be Now?" (keynote address, Environmental Grantmakers Association, Brainerd, MN, October 16, 2001).

3. United States Department of Labor, "National Agriculture Workers Survey," report no. 9, chapter 6, 2001–2, http://www.dol.gov/asp/programs/agworkers/reports9/toc.htm (accessed June 2007).

4. Author's personal journal.

5. Author's personal journal.

6. Author's personal journal.

7. Author's personal journal.

8. Figure from Secretaría de Relaciones Exteriores de México supplied by California Rural Legal Assistance Foundation's Border Project/Stop Operation Gatekeeper, February 2007.

THE MIGRANT PROJECT

Contemporary California Farm Workers

THE MIGRANT PROJECT
Contemporary California Farm Workers

Photo Locations

• Sacramento

• Berkeley
French Camp • • Stockton
• Tracy

• Watsonville
• Prunedale
• Hollister
Castroville •
• Salinas
• Madera
Biola • • Fresno
• Soledad
• Greenfield
• Orosi
• Cutler
Hanford • • Visalia
• Farmersville
• Porterville
Earlimart • • Richgrove
Delano • • McFarland
• Bakersfield
Guadalupe • • Santa Maria Lamont • • Arvin
• Piru
Ventura • • Camarillo
Oxnard •
• Los Angeles
• Indio
Coachella • • Thermal
Mecca • • Oasis
Carlsbad • Oceanside •
Westmoreland • • Brawley
• Holtville
• Calexico

Exhibit Introduction

Rick Nahmias

When envisioning California, most people conjure images of a warm sea-sprayed coastline, redwood forests, the opulence of Beverly Hills, or the magic of Hollywood. It is easy to forget the farmland.

As the sixth largest economy in the world,[1] California's leading industry is actually agriculture, which provides about 50 percent[2] of the produce consumed in this country, amassing $32 billion in annual cash revenue.[3] To put this in perspective, this state's earthly output is far more than three times the combined annual domestic box-office receipts of the entire U.S. motion picture industry.[4] This says nothing of the additional $100 billion in related economic activity that California agriculture is responsible for generating.[5]

Even easier to forget is that of the 36 million Californians,[6] an estimated 1.1 million are farm laborers, without whom this state's vital agriculture economy simply could not function.[7] This virtually invisible underclass, whose days begin in darkness and involve unending hours of stoop labor under the blinding sun for wages that rarely amount to more than $10,000 a year, quite literally feeds our country.[8]

Whether they are families living in the dirt lots of Mecca for months at a time during grape season, tomato pickers in Stockton who dash through muddy fields lugging twenty-five-pound buckets in searing heat, day laborers who rise at two in the morning to cross the border at Calexico only then to be bused seventy-five miles to the scorching onion and melon fields of the Imperial Valley, or workers of indigenous descent who are relegated to the lowest of the low in jobs and living conditions, each and every one of these people has a story. Their stories go much deeper than any single news exposé or any photo-documentary can. They are stories that in their own right have formed a collective saga about the high human cost of putting food on America's table.

Because of the transient, rural, and isolated lifestyles of migrants and the heavy, constant flow of undocumented workers who make up these vast harvesting armies, there is little public awareness of these people. As a result, farm workers on the whole remain one of the easiest segments of our society to both cast off and exploit. For decades, though the languages they speak and their demographic makeup has changed, they have consistently endured our country's greatest hardships in the

areas of health care, unlivable housing conditions, and workplace treatment and safety.

By virtue of the seasonal work they do and how they are employed, often traveling with one particular type of fruit or vegetable throughout an entire harvest, few call any one place home for more than two or three months at a time. This not only keeps farm workers on the outside of the communities in which they live but also splinters families and prevents the growth of meaningful roots. This erodes any firm toehold they may get to negotiate for better conditions with the growers or farm labor contractors.

There are glimmers of hope. Though theirs is an existence rife with struggle, it is this very constant push for survival that drives many toward inventing opportunity for themselves and their families. The emergence of grassroots organizations aimed at curtailing domestic abuse and sexual harassment, the creation of family recreation centers where social services are based and easily accessible, or through the consistent work of tireless unsung heroes and advocates in the farm worker community, against all odds, significant strides from within this population continue to imbue it and its members with a sense of pride and possibility.

While there may always be controversy about the machinations of the political power that provides and controls cheap labor and about the status of farm workers—how they should be treated, naturalized, paid, housed, and who is ultimately responsible for their well-being—this body of work sets out to do one thing: to put human faces on the people who, in the inimitable words of Edward R. Murrow, "harvest the food for the best fed nation in the world."

While traveling nearly four thousand miles across the state to photograph more than forty towns for this project, two things became evident. First, there is no other sector in our country where people have to work so hard to have so little. Second, by adjusting our mentality to one of inclusion and respect, we can welcome farm workers as a meaningful part of our society and understand their intrinsic value, not just for the essential work they perform, but as human beings and individuals who each carry with them the same hopes of many Americans—the dream of a better life. In looking at their stories we take the first step in doing just that.

Notes

1. E. G. Hill, legislative analyst, "Cal Facts 2004: California's Budget & Economy in Perspective," in Legislative Analyst Office (LAO) (Sacramento: Legislative Analyst Office, 2004), 1, http://www.lao.ca.gov/2004/cal_facts/2004_calfacts_econ.htm (accessed June 2007).

2. United States Department of Agriculture, "Vegetables 2006 Summary" (Washington, DC: National Agricultural Statistics, 2007), 8–9, http://www.nass.usda.gov/Publications/Todays_Reports/reports/vgan0107.pdf (accessed June 2007).

3. Jesse McKinley and David Karp, "Persistent Cold Raises Fear In California Citrus Industry," New York Times, January 16, 2007, sec. A.

4. Motion Picture Association of America, "U.S. Theatrical Market: 2005 Statistics," *Motion Picture Association World Wide Market Research & Analysis*, http://www.mpaa.org/researchStatistics.asp (accessed February 2007).

5. April Geary Izumi, ed., "Glassy-Winged Sharpshooter: Winning Battles Today, Preparing for Threats Tomorrow," *California Agricultural Resource Directory 2005* (Sacramento: California Department of Food & Agriculture, 2006), 28, http://www.cdfa.ca.gov/card/pdfs/1cdfa05frontback.pdf (accessed June 2007).

6. State of California, Department of Finance, "California Current Population Survey Report: March 2005," (Sacramento, 2006), i–iii, http://www/dof.ca.gov/HTML/DEMOGRAPH/ReportsPapers/documents/CPS_Extended_3-05.pdf (accessed June 2007).

7. M. Akhtar Khan, Philip Martin, and Phil Hardiman, "California's Farm Labor Markets: A Cross-sectional Analysis of Employment and Earnings in 1991, 1996, and 2001," in Labor Market Information Division, Employment Development Department of the State of California, Sacramento, 2003, 3, http://www.calmis.ca.gov/specialreports/ag-emp-1991 to 2001.pdf (accessed June 2007).

8. United States Department of Labor, "National Agriculture Workers Survey," report no. 9, chapter 6, 2001–2, http://www.dol.gov/asp/programs/agworkers/reports9/toc.htm (accessed June 2007).

Photographs

1. BRACERO RALLY, Los Angeles

This June 2002 rally commemorated the announcement in the U.S.
Congress of the Bracero Act, which would have allowed lawsuits to
continue toward reclaiming the 10 percent of bracero salaries the U.S.
government deducted, transferred to Wells Fargo Bank, and then
supposedly gave to the Mexican government to hold from 1942 into
the 1960s. Hundreds of thousands of braceros were originally brought
into the United States as guest workers to make up for the labor lost to
World War II. Those still alive receive no Social Security benefits or pen-
sions. In late 2005 the Mexican government set up a special fund offering
each bracero thirty-five hundred dollars as a lifetime settlement. Though
more than thirty-six thousand braceros (or their survivors) made claims
for payments that would be covered by this fund, the Mexican govern-
ment has disallowed more than twenty-seven thousand of them because
they were unable to produce the original paperwork (now more than
sixty years old) proving their eligibility.[1]

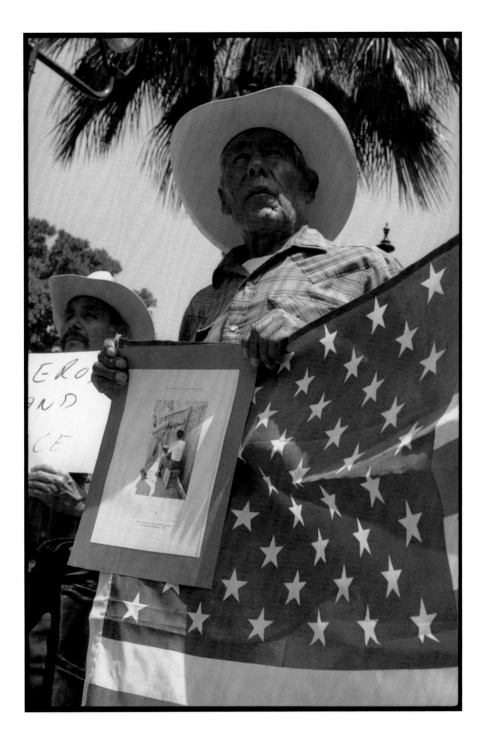

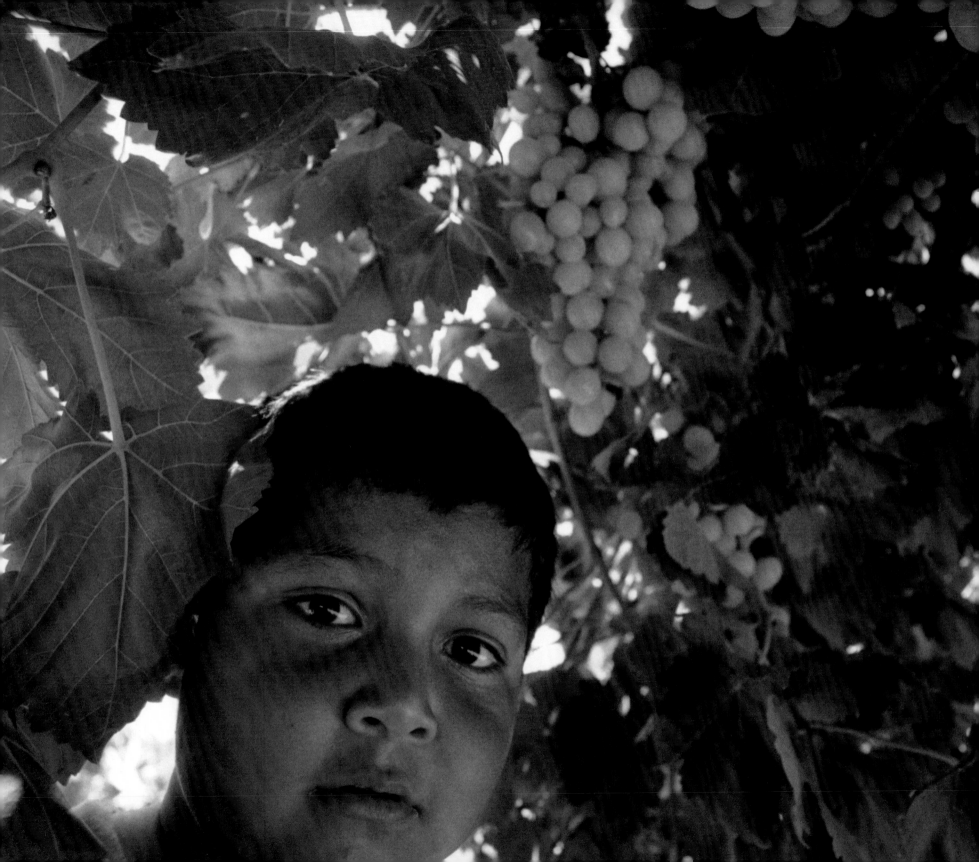

2. BOY IN VINEYARD, Oasis

Victor Hernández, a six-year-old boy from Coachella, takes some time
on his summer break from school to visit the vineyards with his mother,
a community worker.

2. STRAWBERRIES, Guadalupe

Workers fill between 30 to 120 flats a day. The fastest and most nimble
make the most money since piecework is all about speed, though all
strawberry workers must carefully pick and lay each piece of fruit for
attractive display in its respective container or risk having to repack them.
The day of this photograph, the pay was $1.15 per flat of eight baskets.

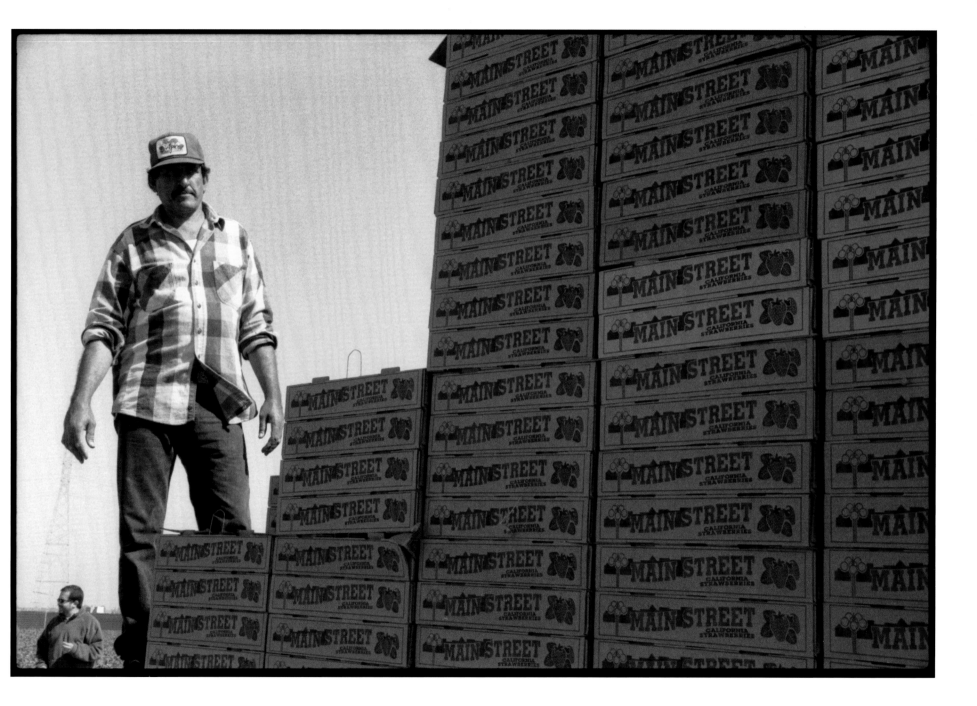

4. PARTY GUEST, Lamont

This woman attends the birthday party of a farm worker colleague.
Though it was the thirtieth birthday of the young woman, not a single
man attended the gathering. It is not uncommon to encounter gender
segregation among male and female farm workers during the few hours
each week they have to socialize.

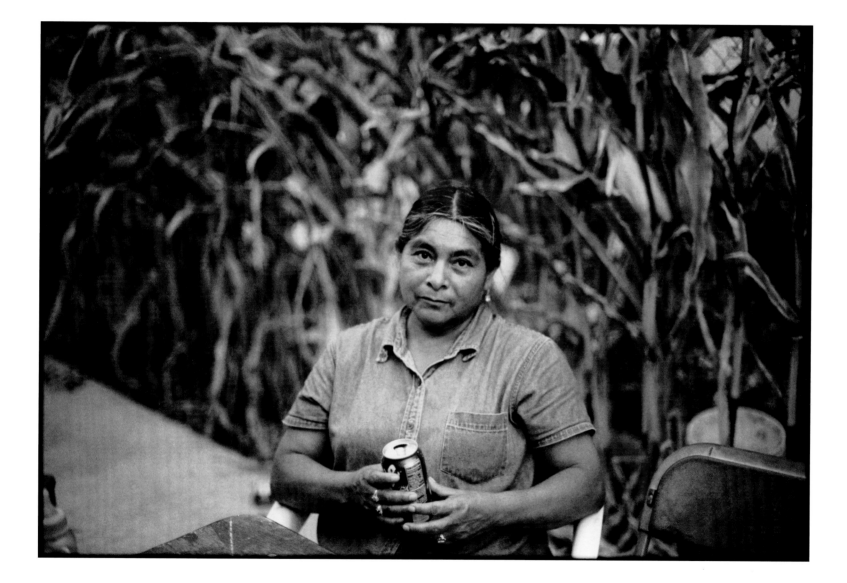

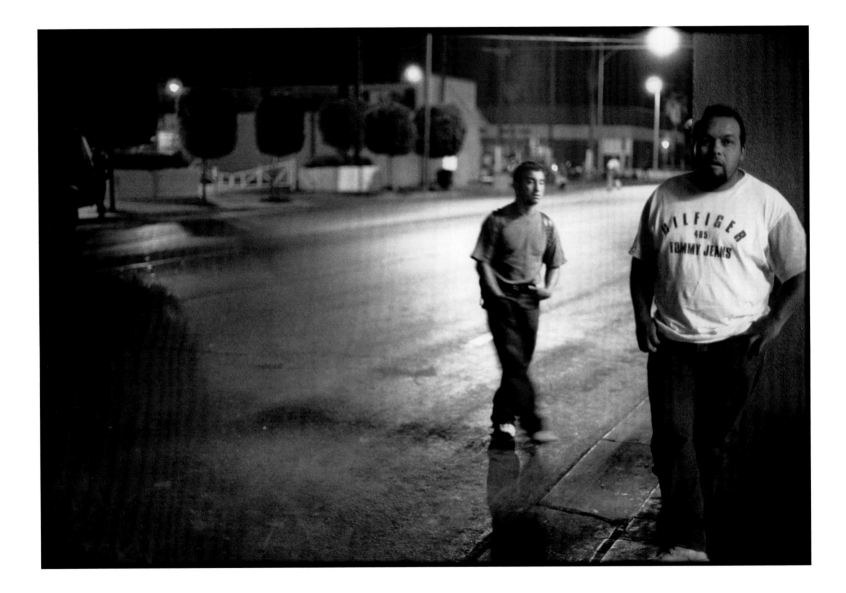

5. LABORERS—1:50 a.m., Calexico

These day laborers cross the border in the middle of the night to begin procuring their next day's work, a process that can take hours. Depending on the crop cycles, on any given day as many as half the workers return home without work.

6. DISABLED FARM WORKER, Mecca

José Cerbere was forty years old when in 1992 he suffered an accident
in a grape packing plant that left him disabled for life. He was awarded
a twenty-two-thousand-dollar settlement but saw only eight thousand of
it. Farm work has only recently dropped from first place to second place
as the country's most dangerous occupation behind mining,[2] but remains
the most dangerous occupation open to U.S. minors.[3]

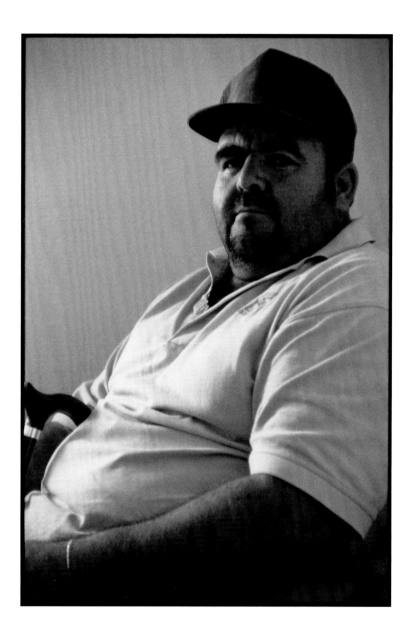

7. EARLY MORNING GRAPES, Porterville

Guillermina Sánchez is a grape worker and member of Líderes
Campesinas, a statewide grassroots organization of farm working
women who specialize in doing outreach to their respective com-
munities on issues of importance to their communities, including
pesticide danger, domestic abuse, and HIV. She arrives at the vineyards
in the dark and begins work as the moon sets. In her free time, she
organizes outreach and pesticide trainings aimed at educating other
farm worker women. One survey revealed 60 percent of the surveyed
farm workers in the Coachella Valley, the first California region to
harvest table grapes each year, reported they were required to "test
the fruit" by eating unwashed grapes during the harvest to find out
if they were sweet enough to be picked. This practice is not regulated
under California pesticide law.[4]

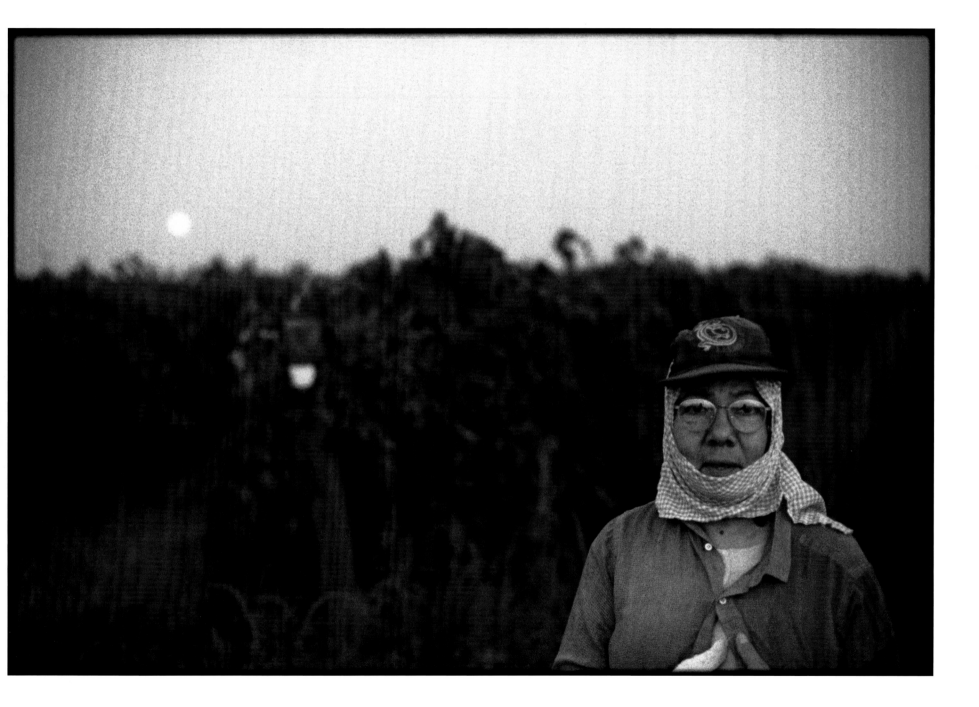

8. KIDS WITH LAUNDRY, Biola

These indigenous Mixteco children live with their parents, five people to
a single room, at a farm labor camp. Their laundry hangs less than three
feet from grapevines, which are frequently sprayed with pesticide without
any warning. Nationwide, 26 percent of migrant farm worker housing
units are directly adjacent to pesticide-treated fields. Among these units,
53 percent lack a working tub or shower, clothes washer, or both.[5]

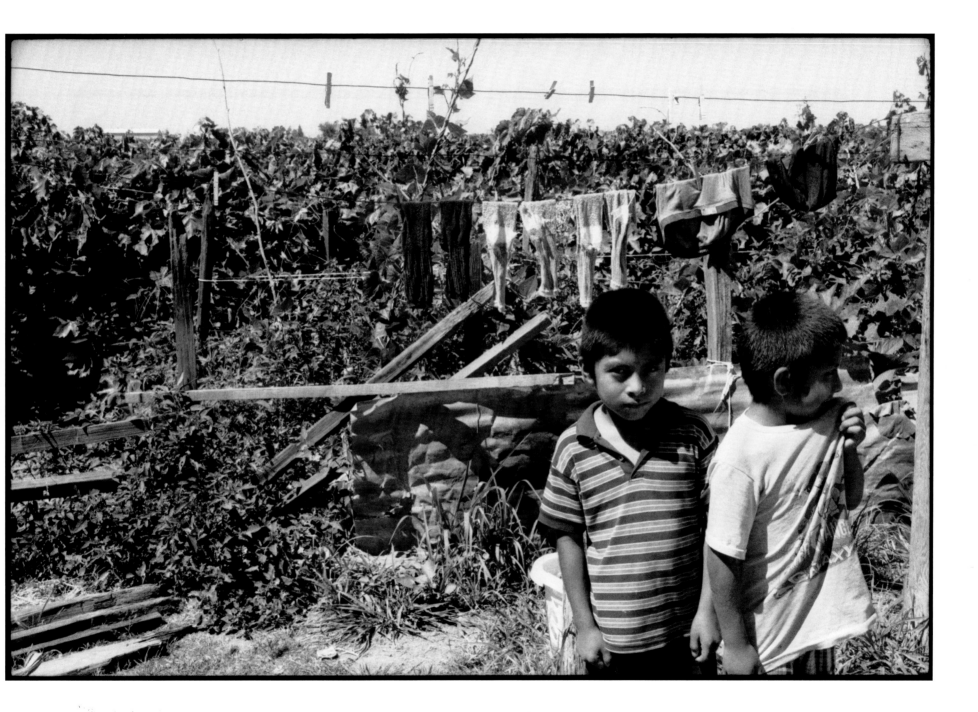

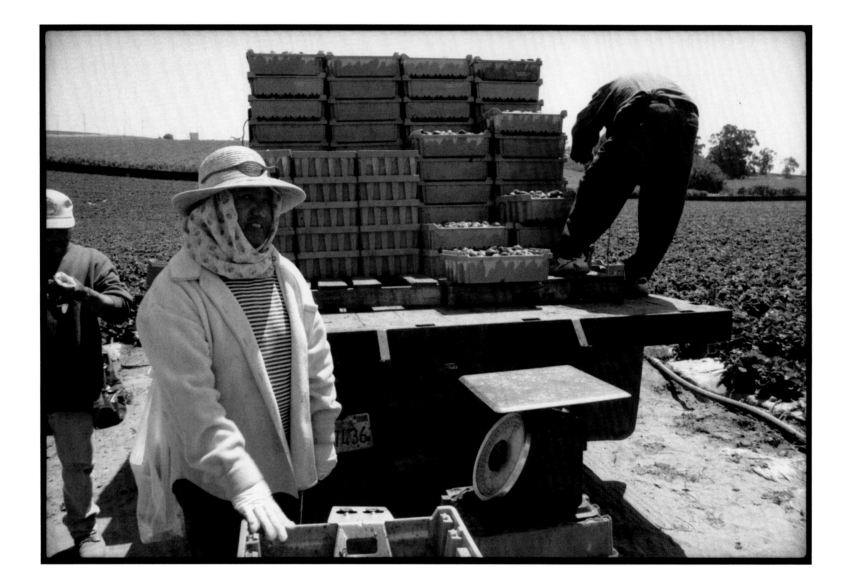

9. SHARECROPPER, Santa Maria

Concha Vásquez finishes her nineteenth year as a sharecropper of pre-
mium strawberries. She and her husband lease the fourteen acres they
farm and the irrigation equipment they use from a cooling company.
The lease agreement requires that she sell the cooling company all her
fruit and that it be packed in cartons that cost her fifty cents more per
flat than they are paid. "For the last two years, we haven't made a living,"
she said, admitting that her son, a financial planner, has had to give
them money to make up the shortfall. "This will be our last season."

10. PITCHING MELONS, Westmoreland

This eight-man migrant team, originating from Texas, earns ten dollars per ton each of watermelon pitched. They estimate that on a good day they make eighty dollars each for six hours of work. This comes out to eight tons of melon tossed per man, per day, without the aid of back braces, gloves, or any other safety equipment.

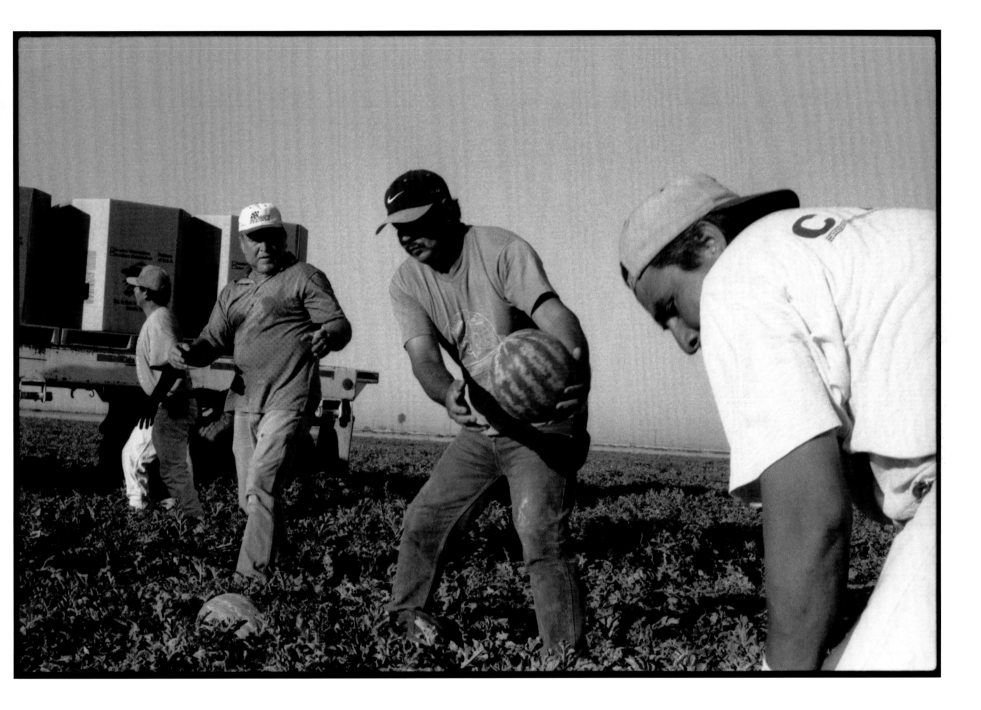

11. MASKED WOMAN—5:30 a.m., Salinas

This woman wears the traditional attire for female field workers. The covering not only helps guard against sun damage but also prevents the detection of underage workers. There are anywhere between three hundred and eight hundred thousand child farm workers laboring in the United States agriculture industry. Being paid as little as two dollars per hour, they often work twelve-hour days and during peak harvests, may work fourteen hours a day, seven days a week.[6]

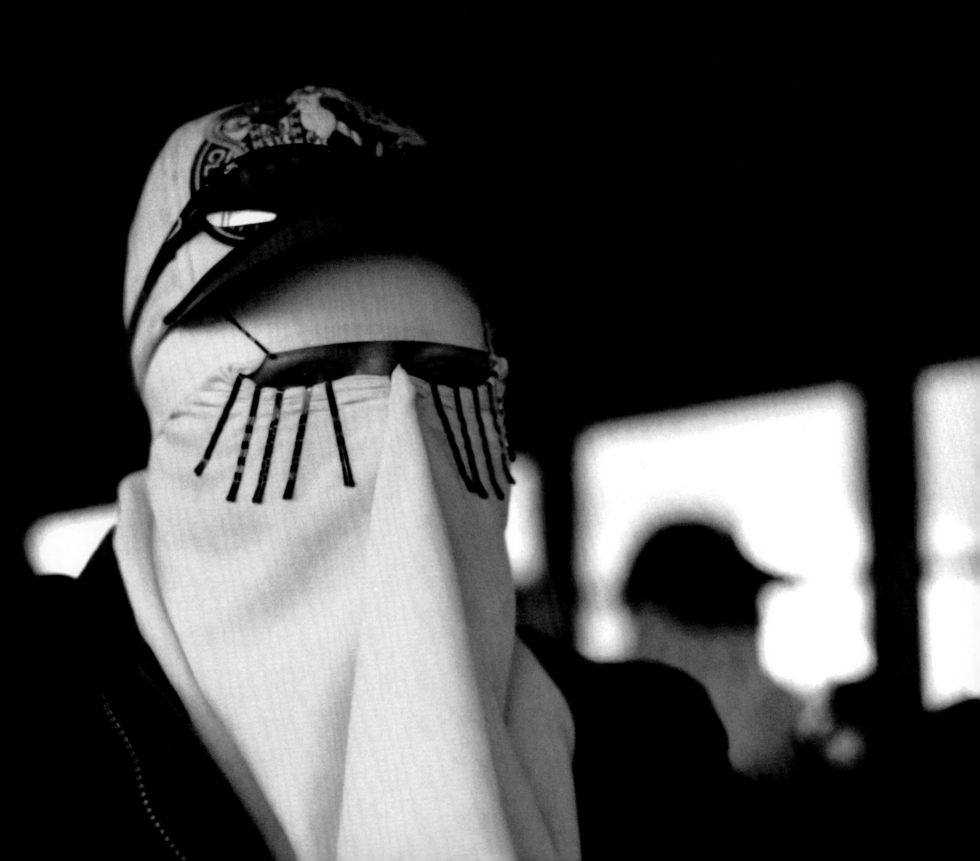

12. THE PAYCHECK, Calexico

This man holds a $74.08 paycheck, his net earnings for two full days
of work. Too tired to cross the border and return home to Mexicali after
a day's work, he sleeps in the railroad yards that double as an end-of-day
migrant depot. Some time after midnight, he will go out and begin
looking for his next day's work.

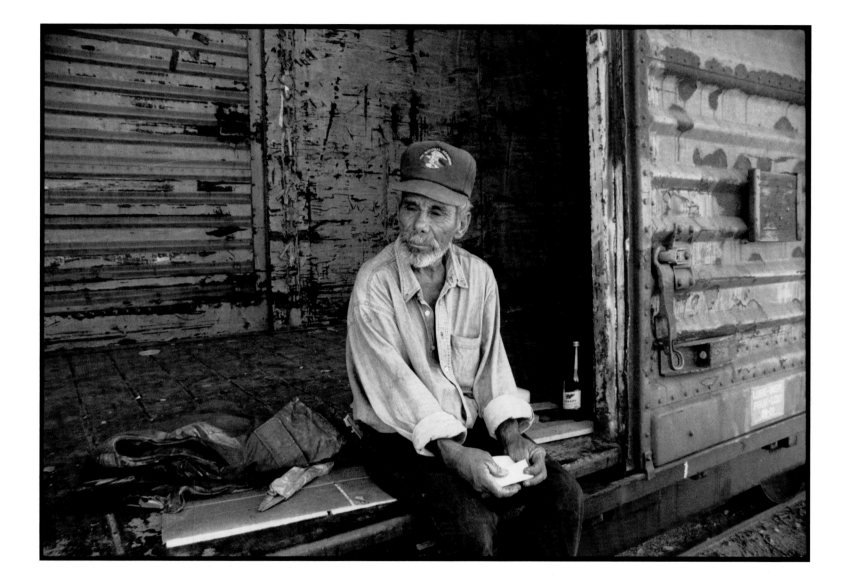

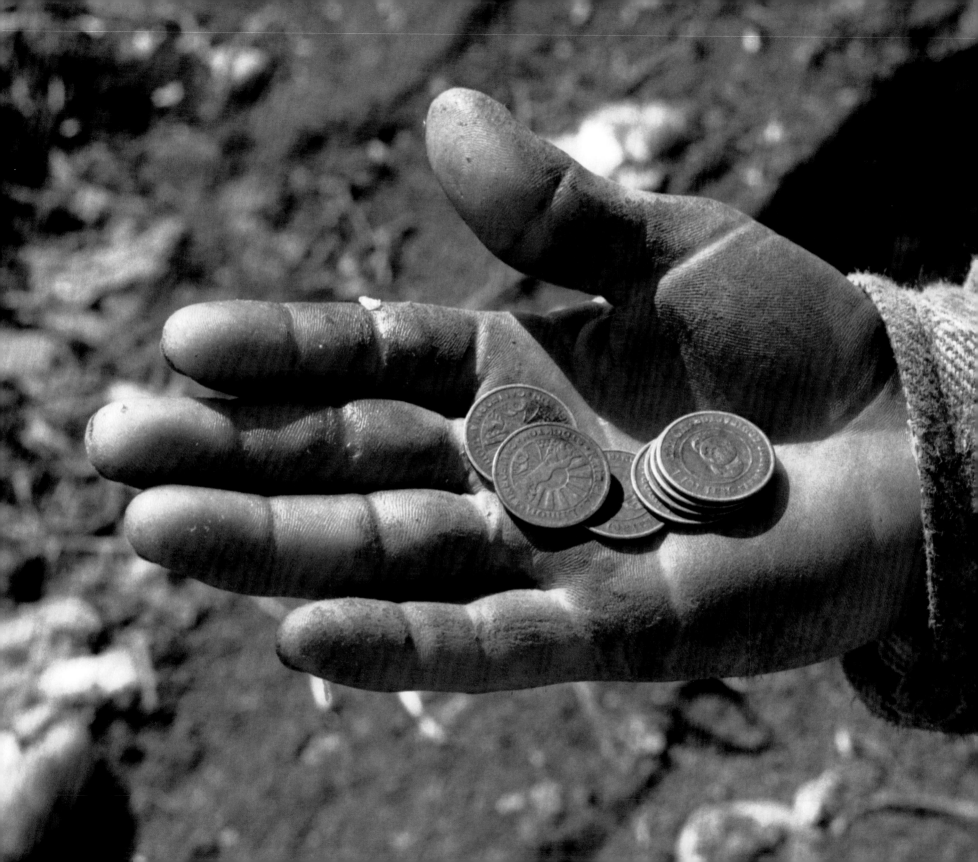

13. TOMATO TOKENS, Stockton

Tomato workers are given one token for each pair of buckets they fill, with each pail weighing approximately twenty-five pounds. The value of the tokens fluctuates with the market price of the tomatoes. On this day, the tokens were worth ninety-five cents.

14. DAY OFF, Orosi

Originally from Zacatecas, Mexico, Carmen spends his one day off a week
on this street corner selling the corn and watermelon he has gleaned from
the fields he works to earn extra cash. Away from his family for six months
at a time, he has lived the migrant life-style for twenty-two years.

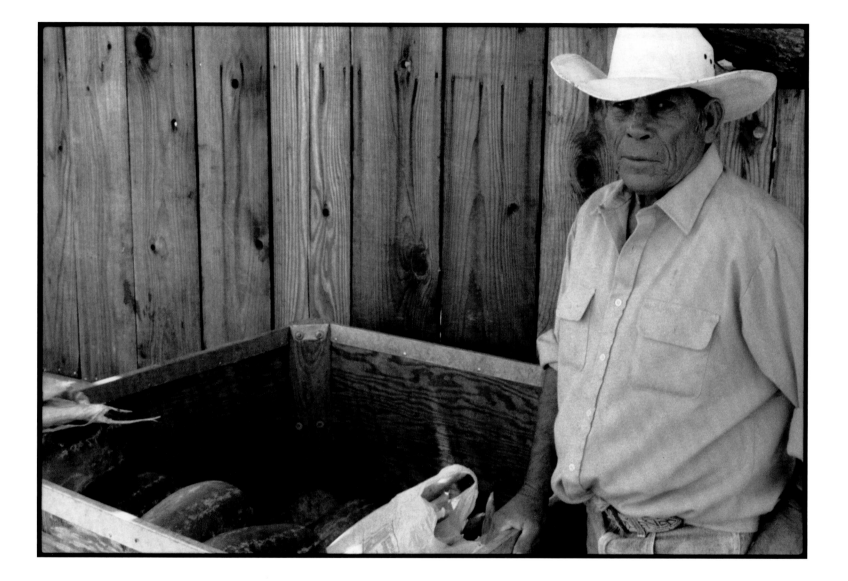

15. SWIMMING IN THE CANAL, Cutler

The children of the Pérez family and their pet chicken bathe daily in this irrigation canal next to where their father, Maxim, picks oranges. With no signage posted, when asked if they were concerned with the possibility of pesticides in the water, their mother, who works in a local packing plant, shrugged a simple, "No." Among other ailments, migrant workers have a 59 percent higher risk of contracting leukemia, and 69 percent higher risk for stomach cancer than other Hispanics living in California, rates that have been directly attributed to their exposure to pesticides and other chemicals used in their work.[7]

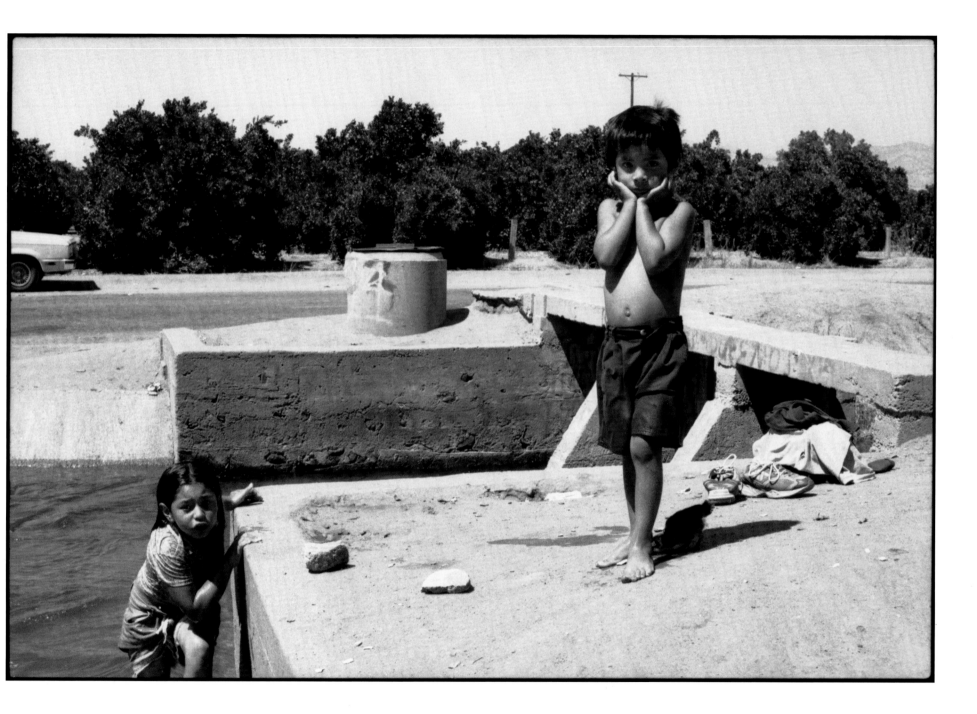

16. MIGRANT SCHOOL PAGEANT, French Camp

Children take part in a celebration marking the conclusion of a summer
exchange of teachers between the United States and Oaxaca. At this par-
ticular school, nearly all the children come from farm worker families.
Migrant children typically complete 7.7 years of school compared with
12.5 years for the general population.[8] Nationwide, more than 50 percent
of migrant children do not finish high school and therefore usually find
few alternatives to farm work.[9]

17. BUILDING HOUSES, Farmdale

Since 1965 more than fifty-five hundred homes have been built in the
Central Valley by Self-Help Enterprises, an offshoot of the American
Friends Service Committee, with most going to farm worker families.
Participating through a program that involves forty hours a week of sweat
equity, family members do everything from laying the foundation to
doing electrical and plumbing work.

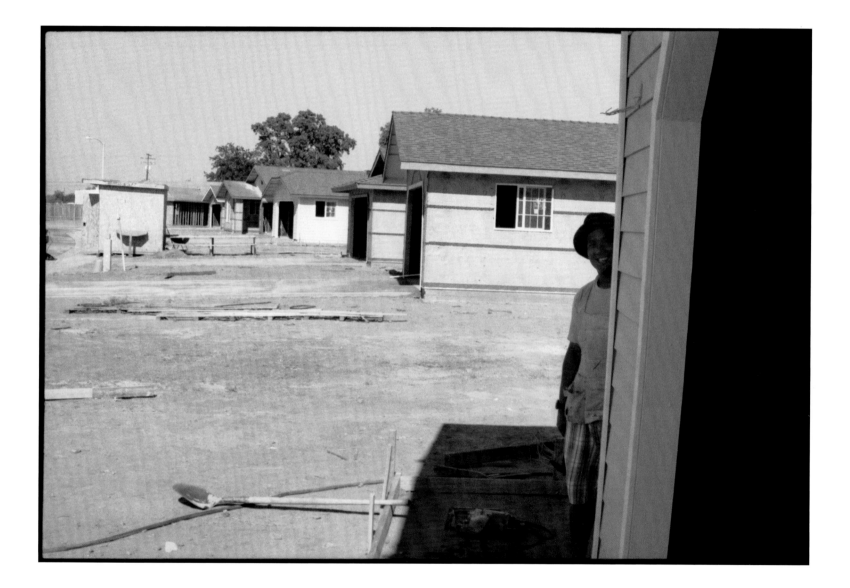

18. CAMPESINAS—3:15 a.m., Calexico

Each morning, as early as 2:00 a.m., these women travel from Mexicali to the Calexico port of entry. They wait to board work buses that transport them as far as seventy-five miles north for their work in the cantaloupe fields of the Imperial Valley. Women comprise about 21 percent of the farm worker labor force.[10]

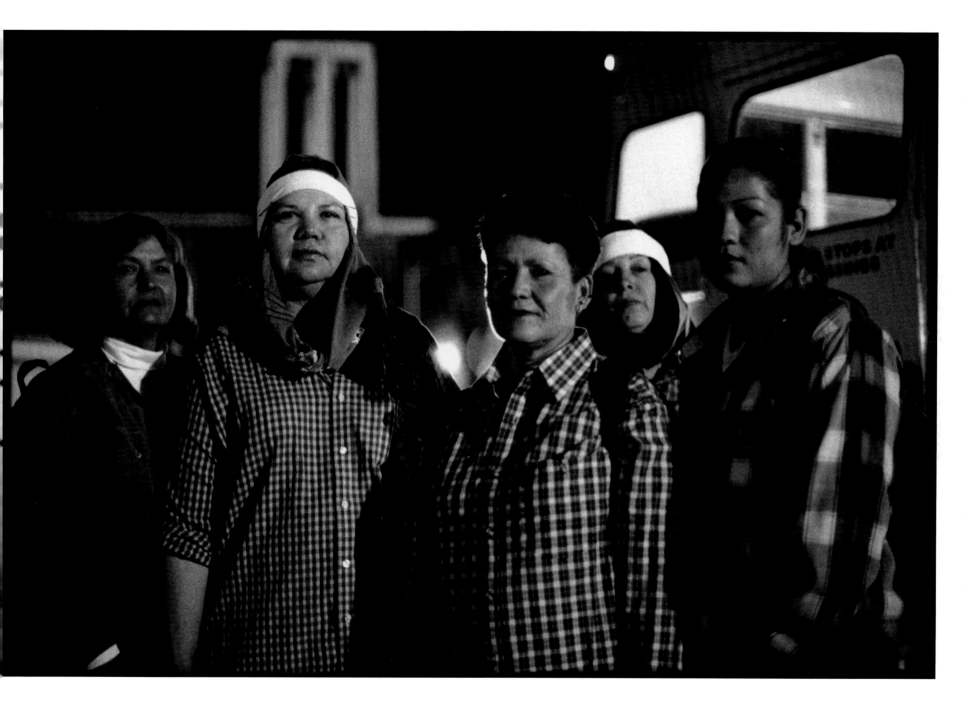

19. ONION SACKS AT DAWN, Brawley

California is the nation's largest onion producer, growing 25 percent of the country's onions.[11] Onion field work almost always starts before dawn, often-times lit by the headlights of buses. Work usually finishes by two in the afternoon because of triple-digit heat. The piece rate paid for onions on this day was sixty-five cents per sack.

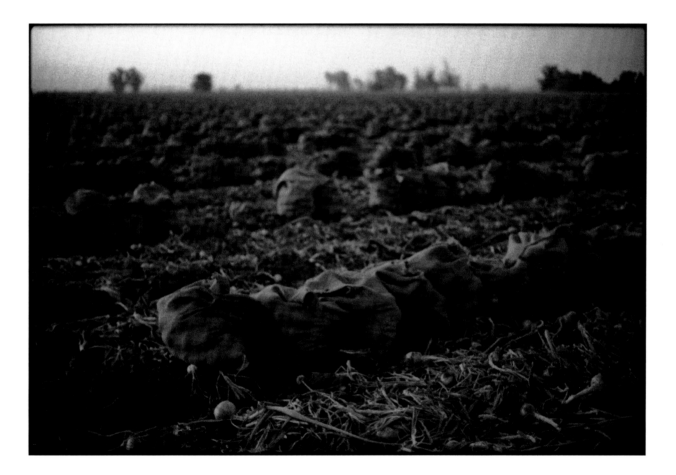

20. MIXTECO MAN, Biola

This Oaxacan father and his four sons put up with substandard housing and work conditions so they can be closer to the crops and lose less money commuting back and forth to the fields. As indigenous workers, they often face discrimination and further exploitation from the general farm worker community because they do not speak Spanish. One indigenous activist who has watched this pecking order develop for more than a decade explained, "They know they're being exploited, but are very limited in their ability to defend themselves."

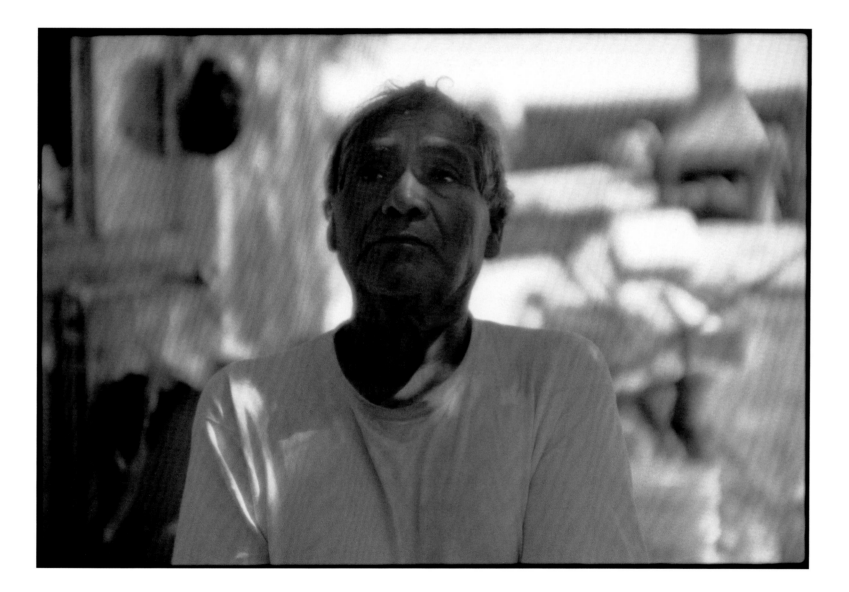

21. SHOES, Santa Maria

Shoes belonging to strawberry workers are piled outside a motel room at
nine thirty at night. During peak strawberry season as many as ten people
will share a single room meant to house one. Nationwide, 52 percent of
farm worker accommodations are considered overcrowded compared with
only 3 percent of general U.S. households.[12]

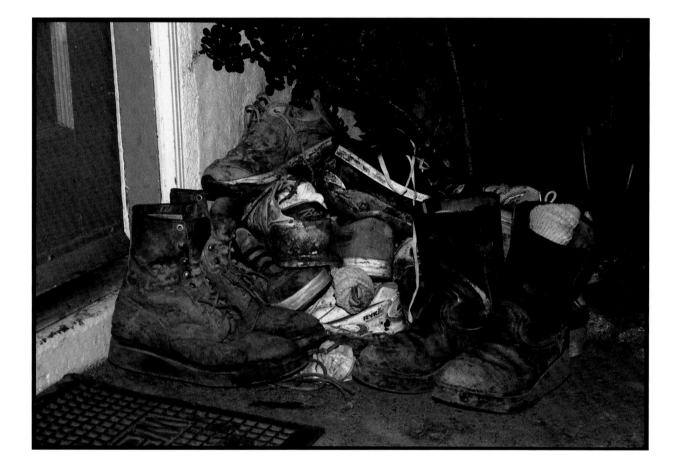

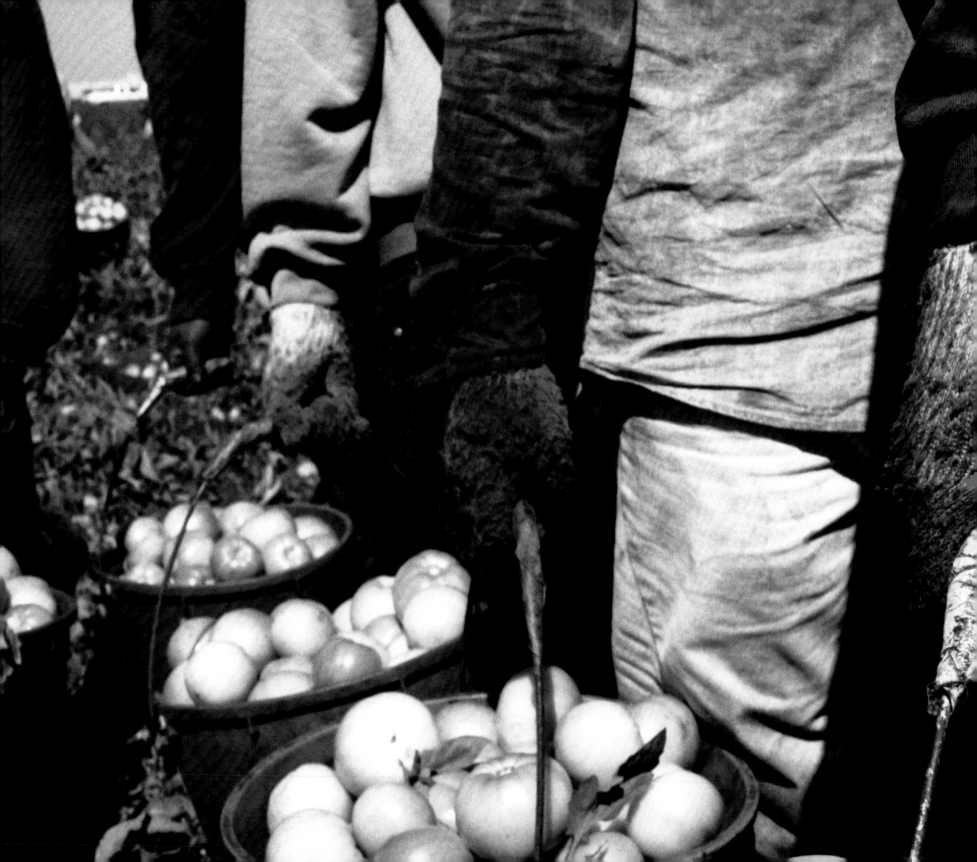

22. TOMATO PICKERS, Stockton

The green tomato harvest is done entirely by hand. Farm workers pick the fruit as fast as possible, tossing it into two buckets, which they then run to trailers. These green, or "fresh market," tomatoes are then treated with ethylene gas to bring about the bright red color. Among the dirtiest types of field work, several layers of clothing are worn to keep workers both protected from the sun and dry from the mud they crawl through. Gloves are worn for quicker and easier handling of the fruit.

23. WAITING—2:48 a.m., Calexico

A farm worker holds his seat on a labor contractor bus headed for the onion fields of Brawley. Though the bus will not leave for nearly two hours, workers must remain on board (without pay) to keep their seats or else risk losing the day's work to someone else.

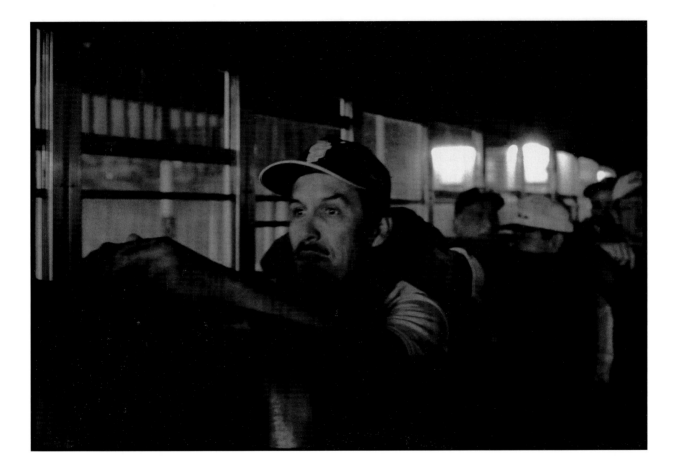

24. PUNCH CARDS, Guadalupe

Though some growers now use computerized systems to keep track
of output and gauge worker efficiency, this old-fashioned punch card
system is the most prevalent. For one flat of strawberries (each containing
eight pints) a worker receives one punch. Strawberries are one of the
most labor-intensive crops as they cannot be picked by machine and
thus depend on stoop labor for their harvesting.

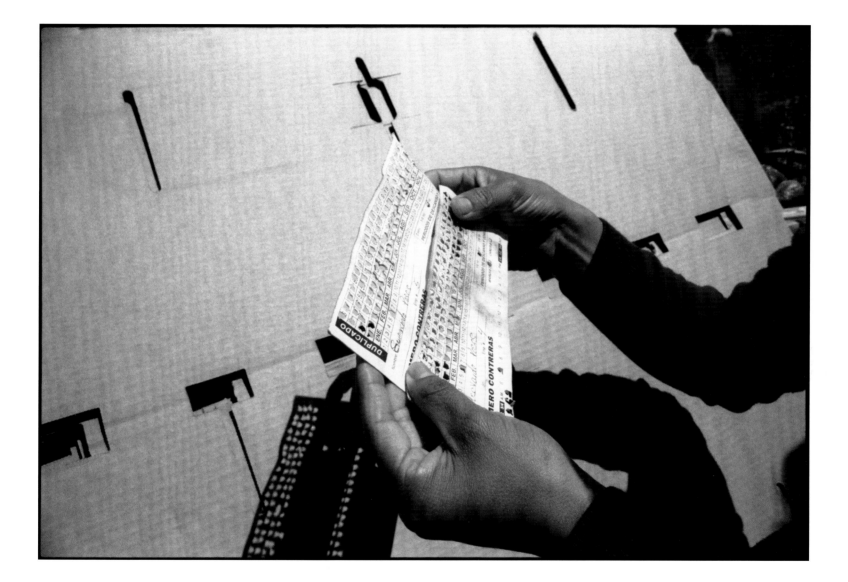

25. CHARRO, Tracy

A participant in the charreada, or rodeo. Very strict regulations on the
dress of participants require all items worn, from spurs to saddles to
sombreros, be made in Mexico; Velcro is strictly forbidden. Approximately
one-third of the competitors and audience members are farm workers
themselves, with most of the others coming from farm worker families
where the elder generations were braceros, but where they themselves
have moved on to professions other than field work.[13]

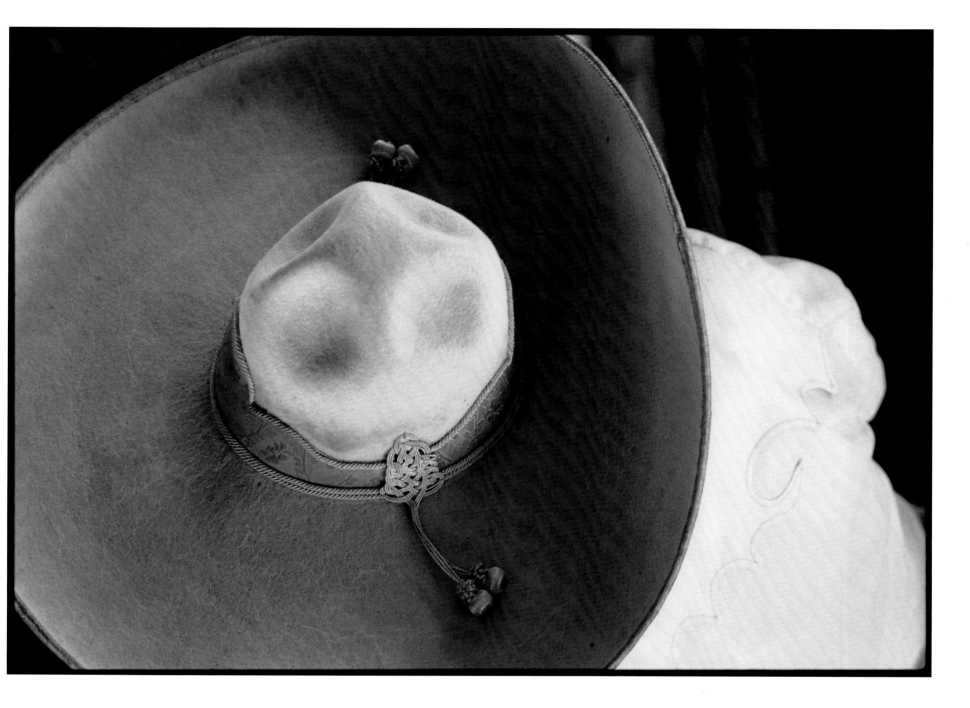

26. ALFREDO, Watsonville

As an openly gay farm worker, Alfredo was fired from his last job when his foreman learned of his sexual orientation. He earns $2.05 per flat, or $0.17 per basket, at this small raspberry farm near his home.

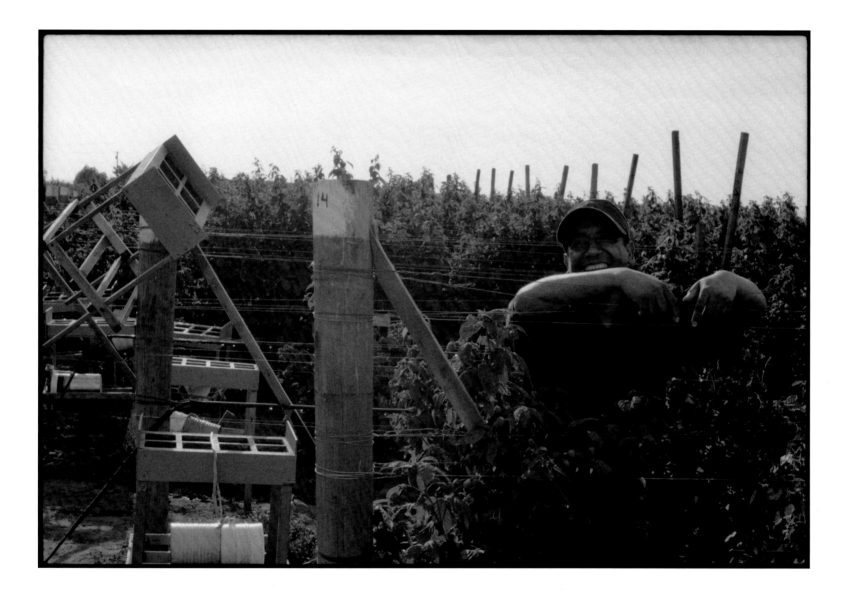

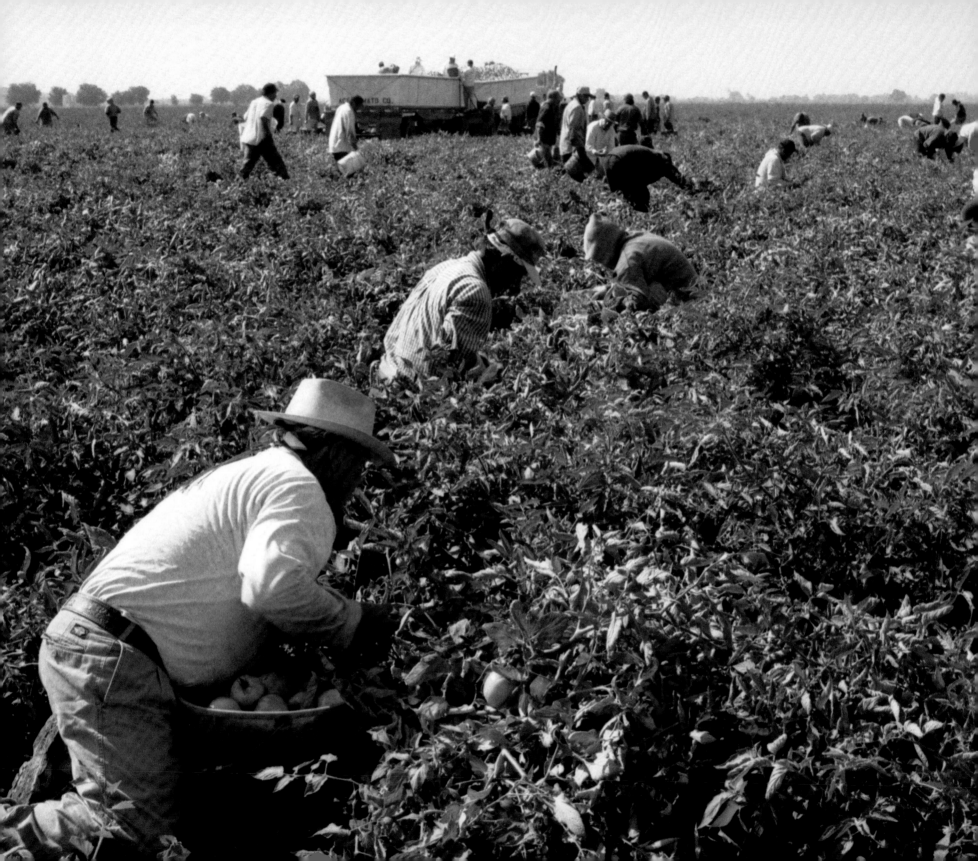

27. TOMATO FIELD, Stockton

To avoid possible damage to the tomatoes, picking cannot begin until the fruit is dry. Since tomatoes are paid on a piece-rate basis, before beginning work, workers may need to wait several (unpaid) hours after arriving at the field depending on weather conditions. Most pickers get jobs on a first-come-first-hired basis, developing into skilled teams on which pickers who prove least productive drop out. The national leader in processed tomato production, California's peak season runs July through September when harvesting can run twenty-four hours a day, accounting for nine out of every ten tomatoes processed in the United States, with a crop exceeding $547 million annually.[14]

28. MARÍA, Bakersfield

In 1998 María's husband phoned her in Mexico to tell her he was dying
of AIDS. After a five-day bus odyssey from Mexico to Salinas with her four
children, they arrived to find he had died one day earlier. Unknowingly
infected by him with HIV, and now too ill to work, she depends on the
programs of Clinica Sierra Vista and their AIDS outreach clinic to pay
her rent, feed her family, and manage her health. Because of the nature
of migratory labor in the United States—predominantly young men away
from home who have unprotected sex with female prostitutes and other
men, high levels of drinking, some IV drug use and needle sharing for
the purposes of vitamin injections, low education, language barriers, poor
access to prevention services, and about a 53 percent undocumented work
force—many experts believe migrant farm workers will be the next group
to see a dramatic rise in HIV infection.[15]

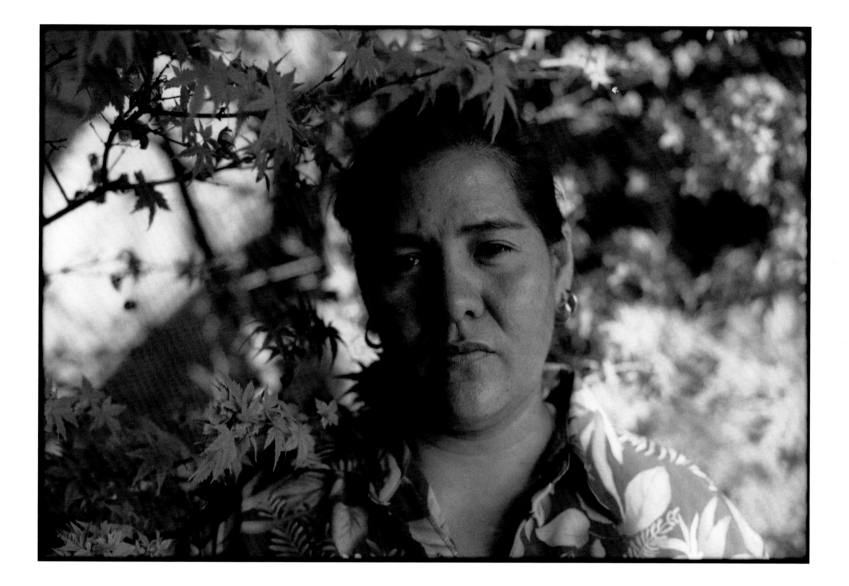

29. SCARS, Stockton

Manuel Llamas is a farm worker who sustained work-related injuries on both sides of the border. After his hand was caught in a machine at a shoe factory in Mexico, he migrated to California. He is now recuperating there from a debilitating injury in 1994 when his leg was pinned under a truck in a cherry packing house.

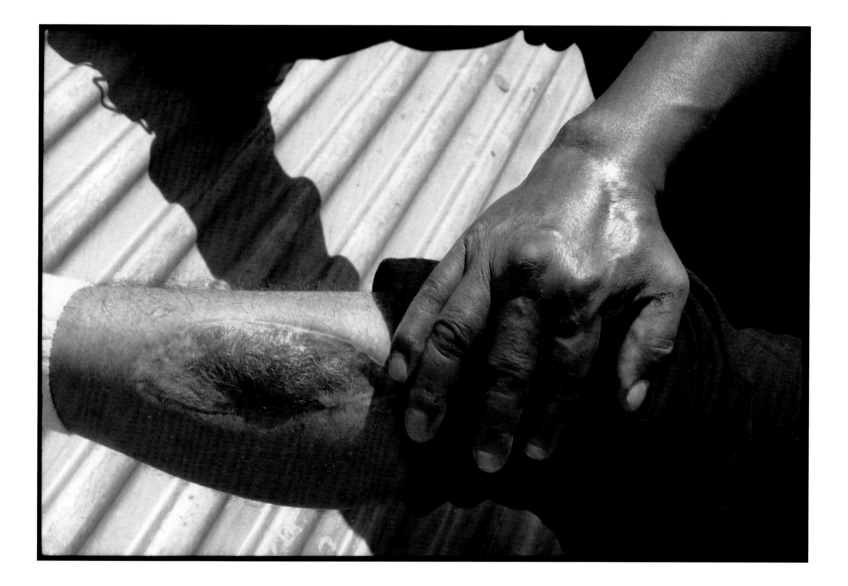

30. HILLSIDE HUT, Carlsbad

Salomón Sebastián Hernández, originally from Oaxaca, has been living
in this six-by-six-foot hut for the nearly two years he has been working
the fields of coastal San Diego County. Unable to stand up inside his
home, which is roofed with a patchwork of shower curtains, tarps, and
cardboard, his single luxury is a tape player charged by a car battery.
With no electricity or running water, the exclusively male community he
is part of must hike twenty-five minutes to bathe in the nearest creek and
contend with raw sewage that flows freely in these ravines that separate
the multimillion-dollar estates of Rancho Santa Fe.

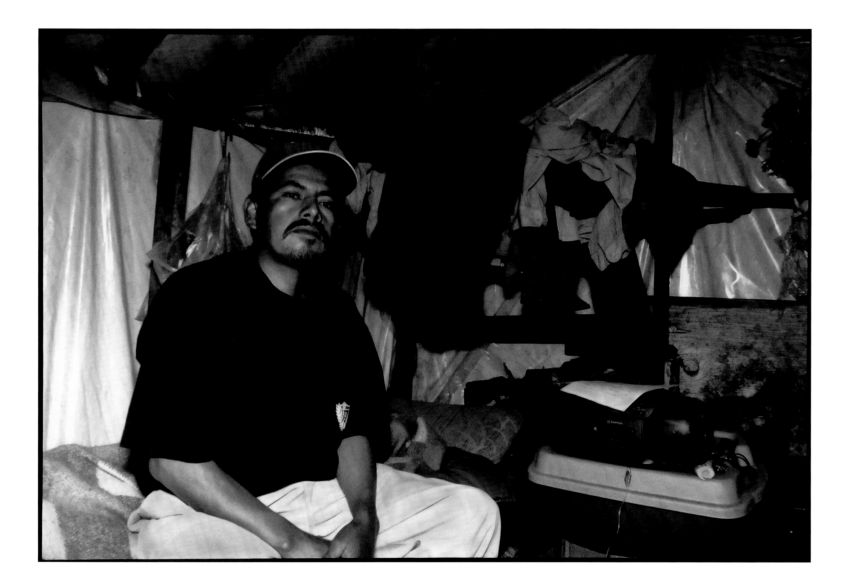

31. SALVADOR, Mecca

Salvador Hernández and his family have been living the migrant life-style for fifteen years. They spend five to six days for most of the year working the various grape and citrus harvests in California and Arizona while their children are taken care of by the grandparents in Yuma, Arizona. On the one or two days they have off each week, they commute back to Yuma to visit their children. They explained they enjoy the migrant life-style but have grown extremely frustrated by the lack of housing. A new migrant housing project that has eighty-eight beds was opened here in 2003 at the cost of $1.7 million, but it has had little effect on the influx of as many as twenty-five thousand farm workers to Mecca at peak grape season.

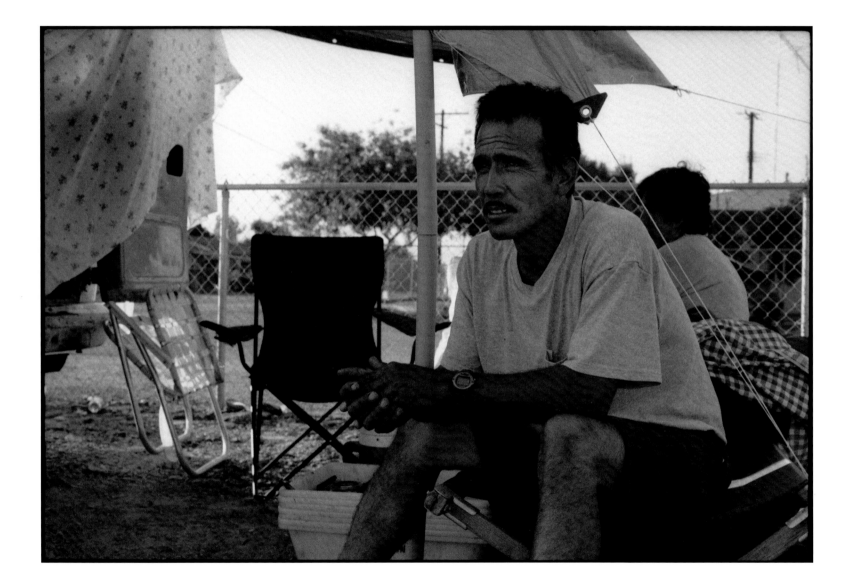

32. LIVESTOCK AUCTION, Greenfield

A farm worker and his grandson contemplate a purchase at the Sunday
sale of livestock. Many local farm workers raise their own chickens and
small animals for food, as a means of side income, and as pets.

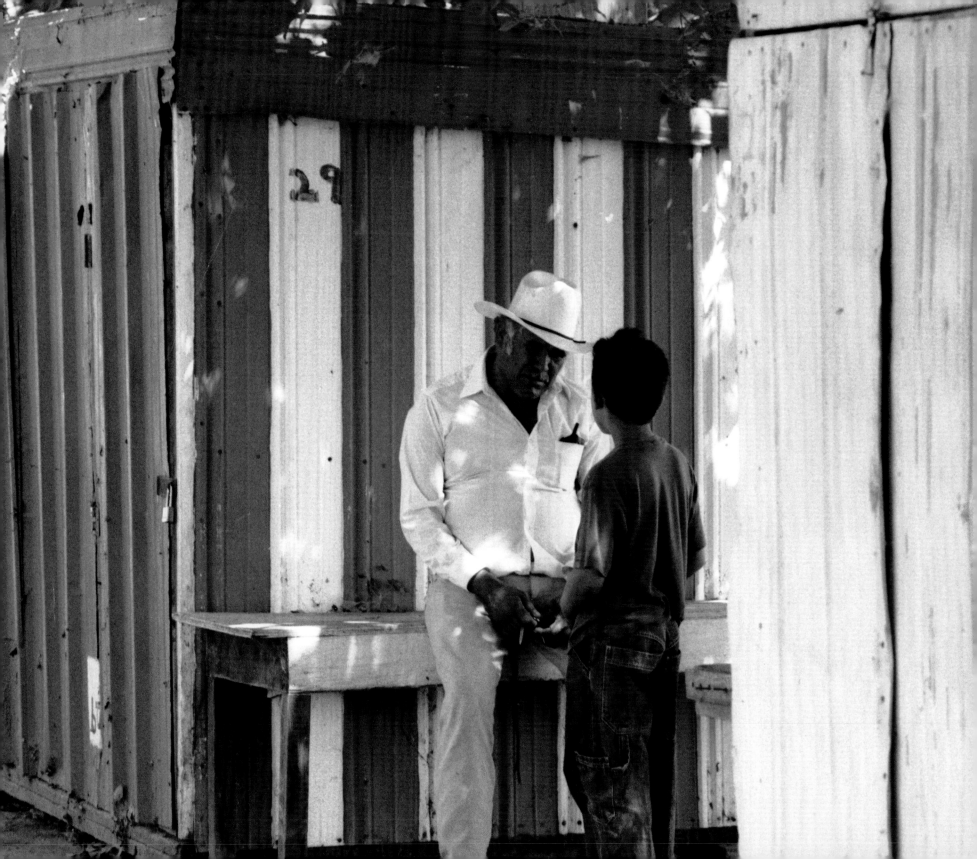

33. GRAPE WORKER, Oasis

Some migrants find great personal and spiritual satisfaction in the work
they do. One worker in the area explained he does his work for "the sake
of the grapes." As if they had a consciousness all their own, he saw them
as gifts given by God and that it was his duty to tend them.

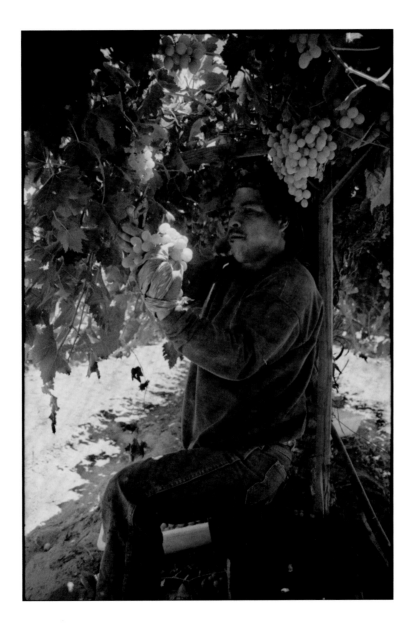

34. CHARREADA, Tracy

In this traditional Mexican form of rodeo from which the American rodeo grew, men and boys compete for national titles, but no money ever changes hands and no corporate sponsors exist. It is one of the only sports where every generation of a family can compete. A highly evolved form of recreation, it originated with the Mexican cavalry and field peasants as work but has become a sport of national prominence in many Latin American countries. California is home to more than 40 percent of the United States' 156 national level regional teams.[16]

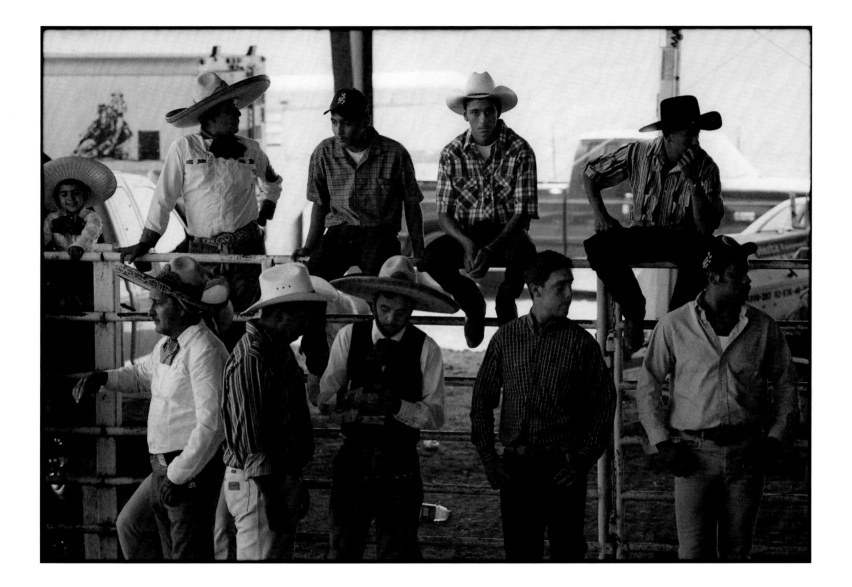

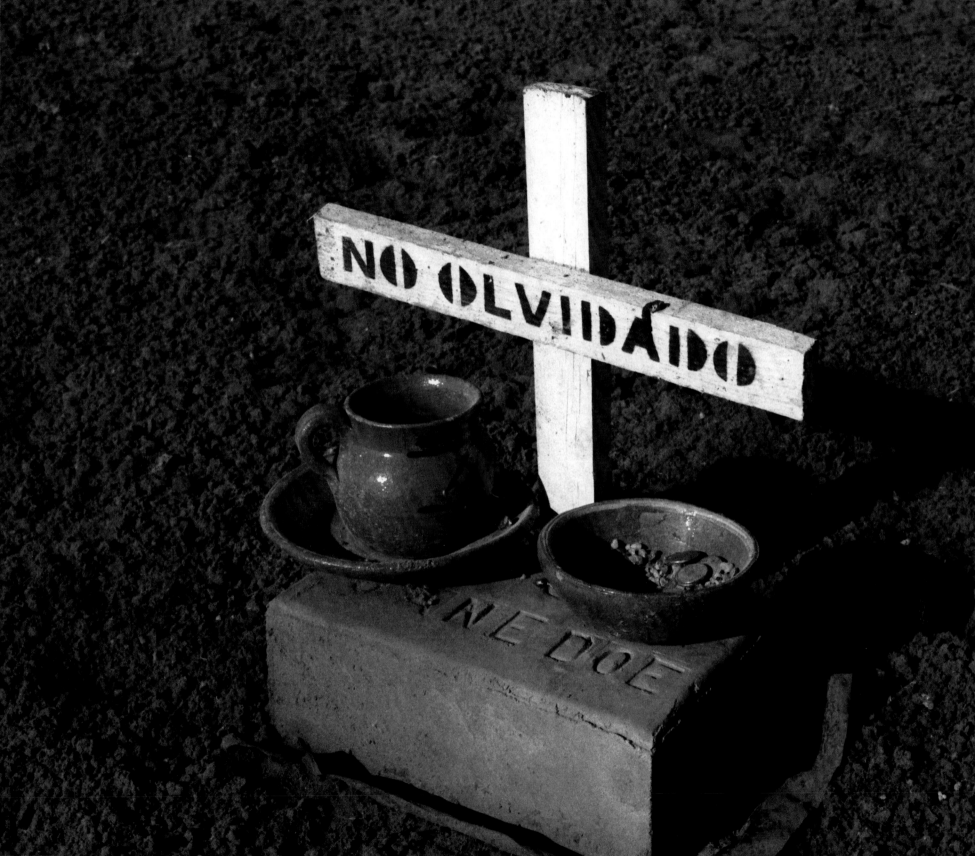

35. NOT FORGOTTEN, Holtville

A grave for an unclaimed migrant body in a potter's field not far from
the U.S.-Mexico border. This dirt lot has become the final resting place
for many who die crossing the border as well as for migrants who die
in America and whose families are unaware of their death or unable to
afford to have their remains sent back home. More than four thousand
people have died along this border since the mid-1990s, which is about
ten times as many as died trying to cross the Berlin Wall during its entire
twenty-eight-year history.[17]

36. MIXTECO KIDS, Oxnard

Since there are few teachers in California schools who speak their
indigenous language, many Mixteco children (originally from Oaxaca
or other indigenous regions of Mexico) do not attend school. Older
children are often left to supervise the younger ones while their parents
work the fields. This ungated apartment complex sits about one
hundred feet from the 101 Freeway.

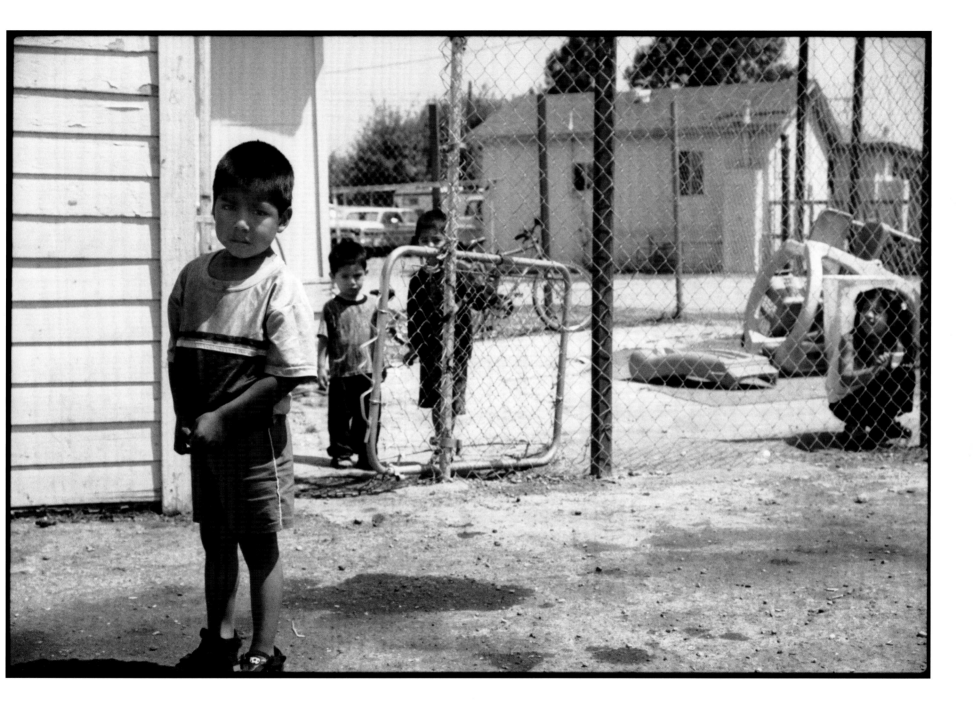

37. MIXTECO BROTHERS, Biola

Indigenous workers from Oaxaca, these brothers, along with their
two other brothers, their father, and three other men, share this
two-room shack on a raisin farm, paying six hundred dollars a month
rent. The other room, a makeshift kitchen, holds another bed and a
stove, all without indoor plumbing. The owner of the farm requires
all occupants to work exclusively for him or forfeit their living space.
At the peak season, lasting three to four weeks a year, they may make
$100–$120 a day.

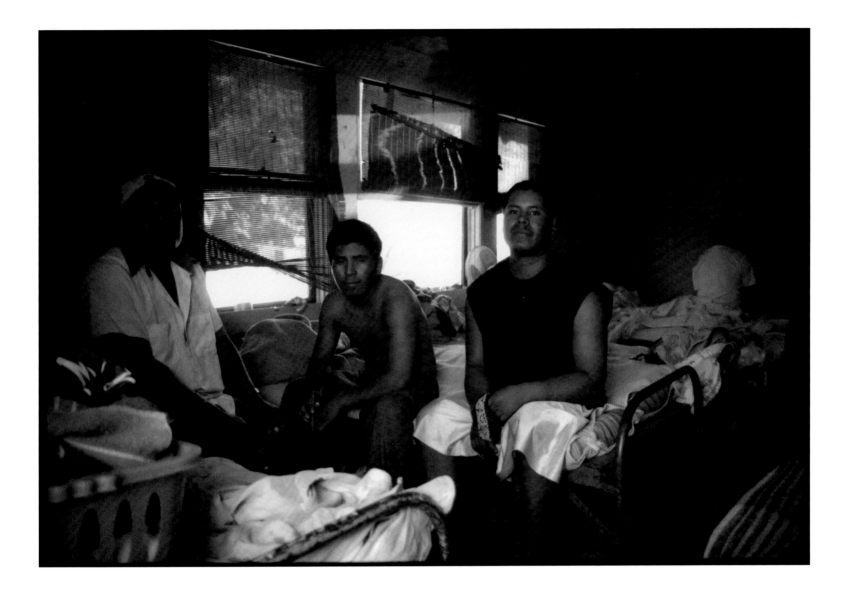

38. JOSEFINA FLORES, Delano

Josefina remembers "the best day of her life" as being the day she joined
the United Farm Workers in 1965 as an organizer, a job that allowed her
to work closely with Cesar Chavez and learn English. Having lost three
of her six children to illness, at age seventy-six she is now separated from
her husband and lives as a retired field worker at Casa Hernández, one of
the first retirement villages for farm workers built by the National Farm
Worker Service Center, Inc., an offshoot of the UFW. With eighty apart-
ments, and nearly two hundred residents in all, it serves people older
than fifty-five with limited income.

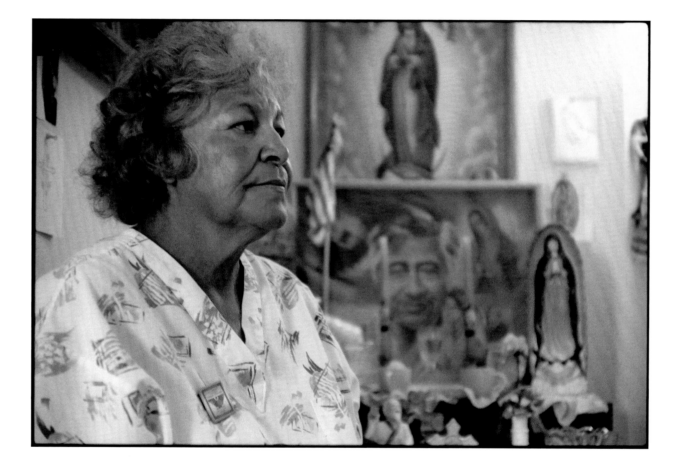

39. EUNICE, Thermal

At eleven years old, Eunice Rebollor was the youngest member of
Líderes Campesinas. Eunice, her mother, Esperanza, and other
women of Líderes from the Coachella Valley, spend several afternoons
each week distributing hundreds of free fire extinguishers and smoke
alarms to many of the nearly three hundred local trailer parks.

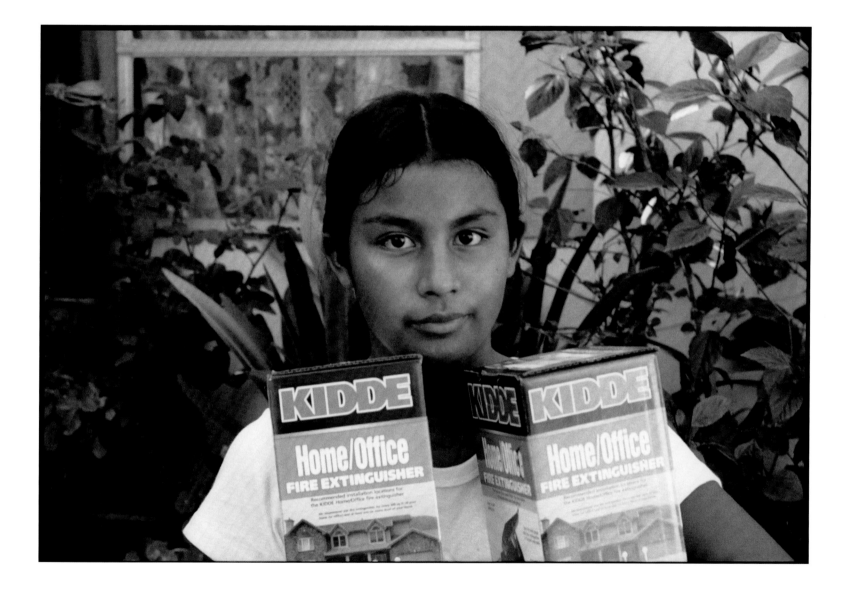

40. MARCH FOR THE GOVERNOR'S SIGNATURE, Sacramento

On August 25, 2002, more than five thousand farm workers, advocates, and supporters marched to the capital, the last leg of an eleven-day, 165-mile-long walk and vigil that began in Merced. The group, here led by Dolores Huerta, the cofounder of the United Farm Workers, Senator John Burton, and current UFW president, Arturo Rodriguez, demanded that Gov. Gray Davis sign SB 1736, legislation that would grant farm workers binding mediation and arbitration in contracts they cannot resolve with growers. On September 30, 2002, former Governor Davis signed a compromise version of this bill. The UFW and their supporters saw it as the greatest legislative victory for farm workers in more than a quarter-century.

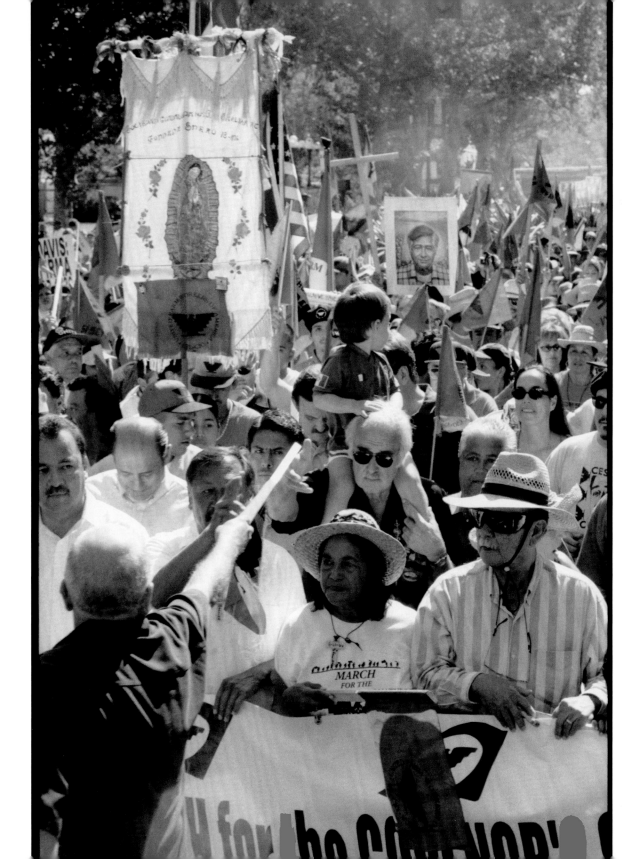

Notes

1. Internet Bankruptcy Library, "Bracero Program: Thousands to Get Money from Compensation Fund," Class Action Reporter 7, no. 252 (December 21, 2005), http://bankrupt.com/CAR_Public/OS1221.mby.

2. John Sestito, JD, MS, Aland R. Lunsford, Anne C. Hamilton, Roger R. Rosa, PhD, eds., "Worker Health Chartbook, 2004," National Institute for Occupational Safety and Health Publication no. 2004–146 (Washington, DC: Department of Health and Human Services, 2004), 193.

3. Lee Tucker, "Fingers to the Bone: United States Failure to Protect Child Farmworkers" Human Rights Watch, (2000), http://hrw.org/reports/2000/frmwrkr.

4. Don Villarejo, PhD, David Lighthall, PhD, Daniel Williams III, Ann Souter, RN, and Richard Mines, PhD, "Suffering In Silence: A Report on the Health of California's Agricultural Workers" (Woodland Hills, CA: CA Endowment, 2000), 29.

5. Christopher Holden, "Housing," in The Monograph Series: Migrant Health Issues (Buda, TX: National Center for Farmworker Health, Inc., 2001), 41.

6. Tucker, "Fingers to the Bone."

7. Kristin S. Schafer, Margaret Reeves, PhD, Skip Spitzer, and Susan E. Kegley, PhD, "Chemical Trespass: Pesticides in Our Bodies & Corporate Accountability" (San Francisco: Pesticide Action Network North America, 2004), 16, http://www.panna.org/campaigns/docsTrespass/chemicalTrespass2004.dv.html.

8. Daniel Rothenberg, "With These Hands: The Hidden World of Migrant Farm Workers Today" (Berkeley: University of California Press, 1998), chapter 1.

9. Teresa Méndez, "Changing School With the Season," Christian Science Monitor, February 15, 2005.

10. The National Agricultural Workers Survey (NAWS) report of 2005, based on 2001–2 data, found 79 percent of all crop workers were men. D. Carroll, R. M. Samardick, S. Bernard, S. Gabbard, and T. Hernandez, "National Agricultural Workers Survey: A Demographic and Employment Profile of United States Farm Workers" (Washington, DC: U.S. Department of Labor, 2005), 23.

11. National Onion Association, "About Onions: Bulb Onion Production," http://www.onions-usa.org/about/production.asp (accessed June 2007).

12. Holden, "Housing," 52.

13. Associate of Federación Mexicana de Charro, telephone conversation with author, http://www.decharros.com/federacion/index.htm.

14. California Tomato Growers Association, "Tomato Facts," http://www.californiatomatoes.org/ (accessed June 2007).

15. The NAWS report of 2005, based on 2001–2 data, found 53 percent of field workers are undocumented. D. Carroll and others, "National Agricultural Workers Survey," 3.

16. Federación Mexicana de Charro.

17. Figure from Secretaría de Relaciones Exteriores de México supplied by California Rural Legal Assistance Foundation's Border Project/Stop Operation Gatekeeper, February 2007.

Essays and Oral Histories

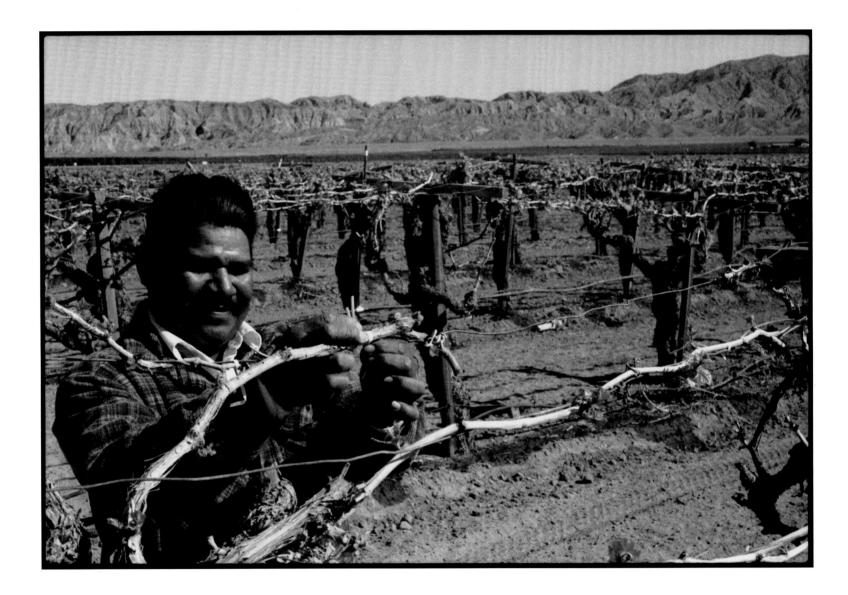

Alberto Juan Martinez:

An Oral History

Anna Lisa Vargas, Oasis, CA, January 21, 2007

I came from Misantla II, Veracruz, Mexico, at the age of thirty-seven, with the intention to better my situation in life and that of my family. Many of my co-workers came here in 2000. I too followed, and with a lot of sacrifice, I made it.

Growing up, I didn't have the opportunity to finish school. I completed the fifth grade where I excelled in math. It was the hope of one of my teachers that I continue my education and attend middle school. When he approached my parents, my father did not agree and instead felt that I should begin to work. As well, the middle school that I would be attending was an hour away from my hometown. (It was only later, at the age of twenty-five, that I attended adult school for over two years and was able to complete the equivalency of a middle school education.)

I decided to come to this country because I knew that I could make a little more money than I was making in Mexico. At first I came alone and had to abandon my family. In Veracruz, I would earn about sixty pesos (approximately five U.S. dollars) a day, and it was insufficient to survive. I laid bricks. That's very

tough work, and my wife would help by mixing the cement when I would get work like putting up a wall or building a house. I also did other work such as deforesting, removing grass with a machete, and caring for animals. Ultimately, I decided to come to this country because life was just too poor in the south of Veracruz.

All of us were aware that people have died in the desert or that the coyotes sometimes abandon people on the way, but I decided to come anyway. A group of us crossed on foot without a guide or any help. Simply, a friend had returned to Mexico and had told us how it was done.

We were in Mexicali, and had been dropped off near the edge of the city. We came in three groups. It was about one in the morning when the Border Patrol caught us. They took us back across the U.S.-Mexico border and made us throw away the food we had brought in our backpacks. Our first attempt failed, and we were then taken somewhere past the Colorado River. Two days later we tried for a second time, and again we were caught by the Border Patrol while attempting to cross a

canal. I had no money and had to begin working in Ensenada. The little earnings I made were sent to my family. I had been working there for about a month when we attempted to cross the border for a third time but ultimately had no luck.

We then got in contact with a man who was from the same town of origin as me. He helped us find a person who knew the way and who was able to pass us by train to California. That's how we arrived. Soon after, I began working as an agricultural worker in the Coachella Valley. After about seven months I began to notice there were women working as well. It was then my intention to bring my wife over. It didn't make sense, her being back home with the situation the way it was—no work. I told her that she could come work, since the jobs here are easy and more plentiful.

So, I returned to Veracruz in 2001 for my family. I brought my fourteen-year-old son, Cesar, who began working the fields right away, and soon after the rest of my family followed. My son and I began in the grapes, where we continue to work. First, comes the pruning (*la poda*), then leaf pulling (*el deshoje*), when a lot of little sprouts appear and you have to remove the excess leaves so that there is enough space for the bunches of grapes to grow. Next is *el desbonche*, in which you have to remove any extra bunches of grapes to ensure that approximately twenty-five bunches remain per vine. This gives the vines a nice shape and allows them to produce about fifty bunches of grapes. Then, finally, comes the picking of the grapes (*la pisca*).

I think we as workers suffer a lot because one always has to be working. The supervisor wants to make sure that output is good. He is constantly saying "the cost, the cost" of the product. If one doesn't put in a lot of effort then the prices go up for the consumer. The foremen explained to us that if the cost of picking the crop is too much, then it will go up at the time of sale. I have to focus on pushing myself to try and maintain a low cost for the consumer. You have to push yourself to the limit to complete the job. It's what is required and what the supervisor wants.

Workers who have been here longer will say, "Don't work fast, the owners already have money," or "Why are you working fast just for them?" They don't realize that while they're not working, the rest of us have to work a lot harder so that the crew completes the job. The foreman will take away our block (our allotted section of work) if the crew doesn't produce enough and we then have to look for work elsewhere. If that happens, then for one or two days I earn nothing. Sometimes you don't even know who the supervisor is. Many times, I've worked an entire day without pay when the output turns out to not be enough. The foreman would send us to another block and pay us for only a day or two of work instead of for all the work we actually did. That happens often, even when I've worked to the best of my ability.

There are some days that are very difficult, like when it's very hot and the dust from the grapevines gets all over your

body. I used to think it was dirt but then learned it is sulfur used to help ripen the grapes. This dust really irritates your skin. Even after I would get home, take a shower, and change my clothes, it still irritated my skin. At night, I still would itch. It makes you not want to return to the fields the next day but you have to. It's your job.

When the grapes are almost ripe, they apply sulfur more frequently, about once or twice a week. Normally, the foremen don't tell us to cover ourselves up. They just tell us not to eat the grapes because they have been sprayed. The men normally don't cover up, but once I saw a man with his face covered, and the contractor asked him, "Why are you covering your face? Only women cover their faces." So from then on, no one covered his or herface. Only during the pruning would they give us safety equipment, but after that, nothing.

During the removing of leaves, it's really important to work hard since it is then that the foreman makes an estimate to determine how much each grapevine should cost the grower to harvest. The amount you pick and the work that needs to be completed is what's important to the foreman, not the health of the worker. There is a lot of dust released from the plants when you are removing leaves, and you get completely covered in it. You have to work fast in order to get all the work done, and you can't be worried about how much sulfur you are inhaling. You just have to keep going.

It doesn't matter to the supervisor if something urgent comes up, or if you had already asked for the time off. The boss will say, "No, we need to finish today," or, "We need to work on another block tomorrow." At times we work the normal eight hours, but at other times we have to work for nine or ten hours. Even if the workers do not want to work overtime, we must or else risk not getting hired the next time. You learn to be very compliant with what the supervisor says.

I think, there needs to be improvements in the worker's salary, so that it's enough to cover all your expenses. Normally, when you arrive, with the little you make, you need to pay off the person who helped you get across. Many people get a loan in their town of origin in order to get here or pay off the coyote. Therefore, the little earnings you make here go to paying off that loan and sustaining your family. Aside from that you have other expenses, like rent, which is expensive.

Sometimes when you rent a place to live there is no concern about the living conditions. Landlords simply place people anywhere. At times, there would be eleven of us to a room. Finding housing when there is none is one of the difficulties. So, you are forced to stay in cramped rooms. There is no other choice. The landlord is the one who profits because he can rent out one room to five people. At one hundred dollars per person, that's five hundred dollars, simply for renting a single room. So, if you decide to live a little more comfortably, then it's two hundred to three hundred dollars per room, and it turns out to be more expensive.

As long as there is agriculture here in the Coachella Valley, there will always be people coming to work. For example, there are currently many people arriving in Coachella from Salinas because it is the harvest season here, but there is no housing so they have to live under the same circumstances—many people to a single room. Sometimes you can't even take a shower when you get home from work or cook, and you just can't live that way. I would say that building more housing for migrant farm workers is required—places where we can live with some small amount of comfort.

I became a Promotor Comunitario because I took a great interest in achieving social justice for my community. A Promotor Comunitario as defined by the Poder Popular Program is "an agent of change, a community health ambassador, and a community advocate." A Promotor is a source of information who seeks to educate community residents to be better informed, empowered, and have greater control of their communities' resources and policies.

There are a lot of inequalities and problems for migrants, therefore we need the community to become more involved and learn about how to exercise its rights. We need to create resident-driven committees where improvements and changes can be made. I would like to see the workers utilize the services that already exist. I mention certain services to my co-workers, but often they'd rather go to work than attend a meeting or an event that will better inform them. This happens because if they lose a day of work that will affect them right now. They need to work. Even if we are were sick, we'd rather receive the earnings for the day.

When I first began working here, I had an ear infection and a fever. I could barely hear. I worked that way for about two weeks until finally I couldn't bear the pain anymore. I did this in order to send money to my six children. I know many who do this. Even if they are ill, they still go to work. Since many have children in Mexico, about every week they send money home to them. So even when I tell them about our community meetings in the evenings and how important they are they say, "I need to earn money for my children so they can eat." Sometimes I feel that way as well, since I have my own family.

During the last few weeks we have only been able to work three days a week, for about five hours per day—or fifteen hours a week total. We should be working forty hours a week, but because of the recent freeze a lot of crops got ruined. Right now we are replanting baby bell peppers. I am also working in the artichoke fields and with other vegetables. The supervisors are sending us to do other work because the bell pepper season has been cut short as well. We are also removing rocks and weeds from the fields, so it will be clean during the replanting. I currently earn seven dollars an hour.

My two oldest children, Lucia Ester (age twenty) and Cesar (age eighteen) also work in the fields. They help me support

the rest of the family. They chose not to continue with their education. We didn't have a way to support their studies. In Mexico, Lucia and Cesar only completed middle school. The rest of the children have continued their studies here. I decided to bring my whole family to the United States so this could happen—so my children would finish school and have a better chance to find a good career. In Mexico they could receive an education but there are not many jobs available. I have cousins in Mexico who have college degrees, and unfortunately they still have to work odd jobs. I tell my younger children that they need to make the effort in order to make it to a university and attempt to receive scholarships because they have told us that the cost of attending a university is very high. My hope is that they will make it, and I tell them to work hard. I don't ask much of them—just to concentrate and do well in school. I see that they really are trying.

I hope they will do well and attend a university so they can have a better job than those of us who have spent our lives working in the fields. This is not to say that working in the fields is a bad thing, but it's difficult. I've always worked in the fields willingly (*de buena voluntad*), and if I had the opportunity to do other work, I would do it with the same effort. I wish I had had a full education, but unfortunately, I didn't have that opportunity. I've had to work in the fields.

ANNA LISA VARGAS grew up in the community of Thermal, California, and is the Program Manager of the Poder Popular Program in the eastern Coachella Valley. She holds a B.S. in Political Science and Anthropology from the University of California, Irvine.

California Farm Worker Defense

A Legal Aid Experience

José R. Padilla

Antecedents: Family Migration
as a Path of Peasants

In his book *North From Mexico*, Carey McWilliams chronicled the Mexican migration from the south of our America, treks that have been a family story for many first- and second-generation Latino families such as mine. Those migrations continue today almost a hundred years later for the same economic necessity that brought my family to California's Imperial Valley in the 1920s. At 35 million nationally and 11.9 million Latinos residing in California (or 33 percent of the state's population), these migrations continue to reshape the face of California. In-state farm workers number an estimated 1.1 million, or 36 percent, of the nation's total farm worker population. At the same time, California Latinos experience the highest number living in poverty and the highest poverty rates among state farm workers enduring the worst of that poverty.

The road these grandparents traveled northward—*al norte*—was a migration of *mejicano* peasantry. They were migrant families carrying on their backs little, but heavy with hope and faith, migrating as crop pickers. The two migrant families who became

our immediate family took paths that differed but came to converge in my border valley of birth—Imperial Valley. One family, grandparents Santiago Real and Dolores Molina, came from the desert of Baja California Sur, the home of the Guaiacura and the Pericué Indians, and traveled through the Sonoran desert. The other family, grandparents Gerónimo Padilla and San Juana Hernández, from central Mexico, came through the Chihuahuan desert. These two families converged in the Colorado desert, a region Juan Bautista de Anza had once traversed 150 years before them on his way to settle San Francisco Bay.[1] Those family migrations would spring children, born on the road—my mother in Somerton, Arizona; my aunt Clara, in Armona (Kings County), California; an uncle also born in Arizona.

By 1927, these families were among the twenty thousand or so cotton pickers in the Imperial Valley.[2] Their experiences in the rural *colonias* were an economic and social microcosm of migrant farm worker life of the twenties, thirties, and forties. Their children's playground was the same cotton fields where parents labored. My family took their place in the cotton fields

after the black families from the South, who had been brought into the valley as the first cotton pickers, had gone urban. The Japanese, Chinese, and Filipinos were also recruited to take their place in the fields but had settled differently. Like the black families before them, the Mexican migrants took their place in the "east side" of various towns, places racially demarcated by the railroad track, that indelible American symbol of segregation. This was a valley the famous labor scholar-activist Ernesto Galarza described thus:

> *The Imperial Valley is a scoop in sandy wasteland . . . As water flowed in the Valley from the east human sweat poured into it from the south, the sweat of Mexicans emigrating north in flight from chronic poverty and the turmoil of the Mexican Revolution. With such endowments the Valley became a cradle of wealth.*[3]

In this rural economic system, for the few to have plenty and accumulate wealth meant poverty for the migrant many. Migrant families settled down and worked their poverty, and their unrealized hopes died and were passed on to their children. Along the way, the subsequent generations learned to respect the value of hard work, the hard work of immigrant labor, and respect the people who used their hands so that their families could survive. In the mid-1960s, the few times my father sent me into the tomato fields, which our town's Filipino growers cultivated "vineyard-style," the farm worker labor condition became ingrained in me forever. It was a sobering reminder that

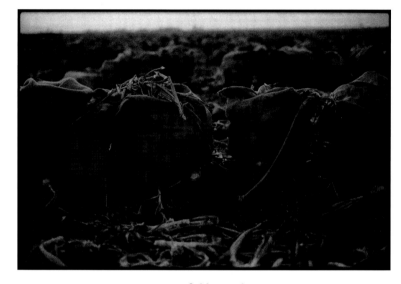

Onion field, Brawley

hard work did not always result in prosperity sufficient to escape abject poverty. This was the familial root that seeded the personal farm worker advocacy to come.

Even before Cesar Chavez and the emergence of the United Farm Workers (UFW), family stories would touch upon tidbits of local labor history, revealing labor activism that had been part of a pattern of major agricultural strife in California. Stories circulated of "tear gas and red-baited" strikes, strikes beginning in the Valley in 1928 and leading to two in 1930 and another in 1934. With the 1951 and 1952 strikes, the name of Ernesto Galarza surfaced prominently as a person who had been a friend of the Mexican working-class community. Later my aunts would reveal proudly

how they had gone to school with Cesar and Richard Chavez and that the Chavez family at times would follow the crops with the Padilla family. Years later, on occasion when I would speak with Cesar and before discussing business, I was struck that he would always ask how my aunts Teresa and Socorro were doing. For a great civil rights leader to take the time to remember my aunts with such a down-to-earth familiarity was reflective of a humility and humanity that was his strength in organizing farm workers. It took the Chavista movement of the 1960s and early 1970s to provide me and the second generation with a message of how law might have a place in a social justice effort. It suggested that access to the legal rights afforded under law was a means to bring basic justice to rural places that had benefited economically from the migrant poverty that had characterized our parents' lives.

My twenty-nine years of work as a staff attorney and state director of California Rural Legal Assistance (CRLA) have been my effort to create the *justice* that was never even an expectation in the minds of most migrant working families from the Valley. CRLA has, in its forty-year history, sought to bring about a basic justice for farm worker families and other rural poor who continue to work at poverty-level salaries, live in substandard housing, toil in the fields subservient to the labor contractor system, and who, nevertheless, continue to demand that these inequities be addressed by legal intervention on their behalf. Those efforts are CRLA's enduring legacy.

Migrant Legal Services: Farm Worker Justice and Poverty Law

CRLA's founding in 1966 had a farm worker purpose at its center. Founding membership included farm worker leaders Cesar Chavez, Dolores Huerta, and Larry Itliong, a Filipino farm worker organizer.[4] In 1974, the Legal Services Corporation Act created an independent national legal service free of state political interference, but the compromise law eliminated what was viewed as the more controversial aspects of the Office of Economic Opportunity (OEO) program that had initiated federally funded legal aid.[5] Among the prohibited activities were cases involving school desegregation, nontherapeutic abortions, and the selective service. By contrast, the national will, fighting a war on poverty, believed that law should be accessible even to the most marginal and invisible communities, including farm workers. The law required the examination of the needs of specific communities thought to be particularly isolated in society from the legal system and require a special outreach and focused program. Native American and migrant farm worker communities became recipients of specific funding under the new law.

My lifetime service with CRLA started right out of law school in 1978, six years after Gov. Ronald Reagan attempted to veto CRLA out of existence and when CRLA was just creating its specialized Migrant Farm Worker Unit.[6] In a real sense, my entry coincided with what was a zenith for national Legal Services. Pres. Jimmy Carter's administration funded Legal Services in the late 1970s under a minimum access formula that, in theory and practice, made one

legal aid attorney available for every five thousand poor persons. Under that formula, CRLA had seventy-five attorneys in 1980 and today would have had one hundred, instead of the current fifty-two attorneys.[7] Nonetheless, the failure of the federal government to provide adequate resources to the program and fulfill the promise to the poor to provide full access to the law did not dissuade CRLA from aggressively representing its rural constituents.

The Black Eagle. The symbolism of the UFW's eagle brings contrasting images as I recollect its meanings as an attorney, a believer in social justice, and an aging, self-perceived Chicano activist. As an undergraduate in the 1970s, I participated in an oral history project that took me into the homes of more than thirty Mexican families who had settled in the Imperial Valley between 1905 and 1930. Through this project, I recovered a lost history of immigrant workers in the Valley who had pursued an economic dream in exchange for rural economic and social injustices. One story related to me described in vivid terms how white vigilantes had resorted to tear gas to break up a union meeting at the Salón Azteca in Brawley's east side. In the ensuing melee a young child was trampled and died as a result. Hearing first person how unionization had been so aggressively challenged in the fields my grandparents picked was a revelation to me. These firsthand accounts provided me with a strong foundation to truly appreciate the subsequent organizing efforts of Cesar Chavez. The emergence of Cesar's authentic farm worker union, generating new strikes in those same fields and in the face of the same

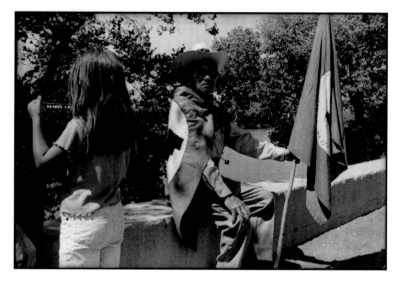

A UFW supporter rests after the March to Sacramento

overwhelming odds, appealed to a second-generation Valley son in the process of receiving a university education. I was not alone in finding the UFW cause meaningful to a generation of Chicano students who were the first in their families to attend college. Cesar Chavez himself came to understand that the UFW movement was both a civil rights and labor movement. It was also an ethnically defined movement, characterized by a newly found ethnic identification and a political activism that demanded justice and equality in the name of "the community"—be it called Chicano, Hispanic, Mexican-American, or La Raza.

It was therefore not much of a reach to go from college activist

in UFW work—being on picket lines at grocery stores or at a field on strike—to law student volunteer work at UFW service centers, and then to choose to become a rural legal aid attorney. In that scenario, CRLA's use of lawsuits to reform labor practices in agriculture, the educational practices in segregated rural schools serving farm worker children, or the hiring practices of the largest rural employers had the appeal of social justice. At the same time that CRLA work sought to bring such systemic changes, it was also there to simply ameliorate the daily injustices wrought upon working rural families trying to eke out subsistence living from wages that kept them in poverty. These were the same daily issues of poverty my own family, our neighbors, and those who had shared their oral histories with me had confronted.

For myself and other advocates bred on CRLA advocacy, the case of *Carmona v. Division of Industrial Relations* is the seminal example of how law can effectuate positive systemic change. CRLA attorney Moe Jourdane heeded Cesar Chavez's request that legal efforts be undertaken to eliminate the hoeing practice that had left him, and thousands of other farm workers, disabled for life because of back injuries. I recalled my own two days of short-hoe work one winter with an uncle contractor during which I refused to return, using a fever as the excuse so that I would never again handle that "devil's hoe," as field laborers termed it.

The Face of Poverty. Mahatma Gandhi once wrote that recalling the face of the most helpless person you have ever met brings a clarity of value in moments of doubt regarding life decisions.

Those faces walk into CRLA offices daily, with the smaller, non-systemic injustices presented as landlord evictions, threatened loss of mortgages, unpaid wages or wages paid below state-imposed minimums, unemployment denials, a child's school suspension, or a parent's immigration deportation—all as critical in impact on that affected family as the impact of *reform* litigation, such as the short-hoe victory. How the small injustice can become pattern-changing litigation is best exemplified in the first sexual harassment litigation CRLA brought in 1998. CRLA exposed the prevalence of sexual harassment in the fields, a practice rarely spoken of, that included farm worker women being pressured to provide sexual favors in order to obtain or keep their jobs. The client farm worker Blanca Alfaro had unsuccessfully shopped her wage case among private attorneys an hour's drive from her residence before a friend had told her of CRLA in her own hometown of Salinas. Seeking only the recovery of a few weeks' lost wages, she responded to a CRLA paralegal's intense questioning of her employer's general farm worker practices by indicating that if CRLA were so intent on helping people like her, they would do something about the sexual mistreatment of women farm workers at that company. The rather surprised community worker took her story to attorneys who had been seeking such a case to take to the Equal Employment Opportunity Commission (EEOC). After educating the EEOC about the existence of these egregious practices in the fields, CRLA advocates facilitated the first lawsuit of its kind in *EEOC v. Tanimura-Antle*. The $1.855 million settlement in the name of

Blanca Alfaro was the largest sexual harassment award paid out by the agriculture industry. This unprecedented settlement included a claims fund for women farm workers who came forward alleging harassment or retaliation by the company. By 2005, the EEOC had recovered an estimated $4.5 million through litigation and administrative settlements that were made possible as a direct result of CRLA's efforts placing this issue on the EEOC agenda.

Values That Sustain. I have come to learn the simple lesson that the work of social justice is a lifelong commitment. Some colleagues have described it as a marathon that needs its pacing to be sustained. I prefer to describe it less like a race and more like a life principle about how much we are willing to give to a just cause. The few justice teachers who have lived by example show us that you can never "retire" from the work. They fit the poet's description of the committed individual as a "militant of life."

I have also learned that weariness comes as a natural attendant to the justice task. The weariness comes with the daily onslaught of legal cases that seem unending, with the repetitiveness of hard-luck stories that hound hard-knock lives that you cannot help but absorb. It comes with the incessant political interference with work that should be deemed praiseworthy, but is instead attacked from the bureaucratic minutiae of a highly regulated practice. It is these smaller diversions from actual public service that wear the spirit thinnest over time. Yet ironically, it is sometimes the seemingly insignificant acts or words of clients that serve to heal the weary spirit.

- There are the clients who suffer poverty, knowing they do so, so their children do not. Such are the Mixteco farm worker parents who participated in the lawsuit to clean up a toxic waste site next to their trailer park and refused to take a one-time settlement of thirty thousand dollars, opting to wait for a home in a housing complex named for their village a thousand miles away. The parents stated: "We have already gone through our suffering, but this is for the children, so they don't suffer . . . so they grow up healthy and not risk illness that will prejudice them for the rest of their lives."

- There was the Mexican immigrant gardener who had worked fourteen years for a wealthy white family and had not paid a cent because he believed the monthly gardening was his mortgage payment. On the eve of eviction, he expressed the disappointment to his attorney, minimizing the loss of the home with the loss of friendship: "Inside, I knew I probably didn't have rights. But it is not so much that I was losing the house; it is that the owner was my 'friend.' He wrote the letter to the immigration service that brought me into this country as his gardener." CRLA helped him keep the home.

- There are those clients who take personal risk, and do so, so that others will not be similarly treated.

The recovery of dignity has a price, though. There was the farm worker woman who knew the risk of publicity in a sexual harassment suit that she alone had brought. She described her ordeal as having made her feel "ridiculed, trampled on, and abused." The fighting back, she said, had changed her profoundly. Now, she felt unafraid to speak up to defend herself because CRLA had defended her rights. The seven-figure settlement was shared with fellow workers who made similar claims.

- There are also the Doe clients, whom we must shield from public exposure, but who nevertheless risk exposure when they represent the invisible group. These are individuals like the seventh-grade plaintiff in the challenge to a state proposition that would have excluded him and other undocumented children from attending school. I heard him read his "media statement" on a San Francisco playground, stating that when he grew up, he wanted to be "someone important like a scientist or maybe even a soccer player." He said that with the law's passage, he knew his dreams would disappear and wondered where "[are] all the children going to go?" When I asked him if I could copy his words to read at a Latino lawyers' dinner, he gave me the small crumpled paper from which he had read. Fortunately, the legal challenge was successful. I still have his eight-sentence speech.

Faith and Justice Served. In its most effective and idealistic form, legal-services practice is the effectuation of social justice through the enforcement of civil laws. In California, basic access to the civil legal system has allowed many families in poverty, farm workers among them, to realize the promises of economic justice. Through the creation of new laws and the practical use of existing laws, historical neglect is being corrected when even the most marginal of workers, finding themselves in isolated lettuce fields, know that dignity means the employer must provide clean water to drink and a bathroom for the day. It has been corrected when even the farm worker who speaks neither English nor Spanish, but a Mixtec dialect, expects to find a picking field where his health is not endangered by poisons or harvest instruments that will cripple him for life. Those of us whose grandparents survived their lives of migrant neglect know some change has come when a women farm worker explains that her sacrifice doing hoeing labor has meant that the last of her three daughters will graduate in the spring from the University of California, as the other two have done. Indeed we know change has come when CRLA hires a young lawyer whose mother still lives in a labor camp, and the daughter joins her there, choosing a CRLA job because she had been inspired to be a lawyer when CRLA defended the family, years before, from an eviction from that same labor camp.

Implicit in those examples is the belief than any person, citizen or immigrant, can place faith in a system of civil laws, believing these can produce standards of life worthy of a country driven by

deep-seated beliefs in liberty, equality, and justice written into law more than two hundred years ago. CRLA's public service legacy that has promoted the interests of California's most invisible and vulnerable communities has been a test of such principles and a humble testament that the faith has not been misplaced.

JOSÉ R. PADILLA, ESQ., is Executive Director of California Rural Legal Assistance, Inc., a fifty-attorney, low-income law firm that has been serving the rural poor of California for more than forty years. Mr. Padilla has spent his entire twenty-five-year career as a CRLA attorney and the last twenty years as its state director. The organization is considered not only one of the premier legal services programs in the country, but also one of the nation's most effective and controversial defenders of farm worker legal rights.

Notes

1. Don Garate, *Juan Bautista de Anza: National Historic Trail* (Tucson: Southwest Parks and Monuments Association, 1994).

2. Devra Weber, *Dark Sweat, White Gold: California Farm Workers, Cotton and the New Deal* (Berkeley: University of California Press, 1994), 53–55.

3. Ernesto Galarza, *Farm Workers and Agri-business in California: 1947–1960* (South Bend, IN: University of Notre Dame Press, 1970), 146–47.

4. The history of the United Farm Workers Union indicates that Larry Itliong was an organizer with the Agricultural Worker Organizing Committee (AWOC) of the AFL-CIO in 1965, when Filipino workers struck Delano fields "under the AWOC banner." The Chavez union joined the strike, and this became its first strike under the "black eagle flag." See Susan Ferriss and Ricardo Sandoval, *The Fight In the Fields: Cesar Chavez and the Farmworkers Movement* (New York: Harcourt Brace & Company, 1997), chapter 3, 65–89.

5. Legal aid, as part of the War on Poverty, had been initially under the jurisdiction of the Office of Equal Opportunity, which Pres. Lyndon Johnson's administration had created in 1964.

6. For a history of the CRLA difficulties with Gov. Ronald Reagan that led to the creation of the 1974 Legal Services Corporation Act, see Michael Bennett and Cruz Reynoso, "California Rural Legal Assistance (CRLA): Survival of a Poverty Law Practice," Chicano Law Review vol. 1, no. 1 (Summer 1972): 1–79. Also see Jerome B, Falk, Jr. and Stuart Pollak, "Political Interference with Publicly Funded Lawyers: The CRLA Controversy and The Future of Legal Services," *The Hastings Law Journal* vol. 24 (March 1973): 599–646.

7. The California Commission On Access To Justice published "The Path to Equal Justice: A Five-Year Status Report on Access to Justice in California" (San Francisco: California Commission On Access To Justice, 2002). The report indicated that the ratio of state attorney to poor person is one attorney for every ten thousand poor persons. In some CRLA offices, CRLA has one attorney for every twenty-nine to thirty-six thousand poor persons. In general, CRLA estimates that farm workers have one CRLA attorney for every forty thousand farm workers who are eligible for its services.

The Plight and Fight of Migrant Farm Workers in the United States

Kurt C. Organista, PhD

U.S.-Mexico Relations and the Origins of Mexican Labor Migration

There is an old saying in Mexico that humorously captures the love-hate relationship between the United States and Mexico that has spanned more than 150 years: "México, tan lejos de dios y tan cerca de los Estados Unidos" (Mexico, so far from God and so close to the United States). Such Mexican sentiment toward the United States is historically rooted in major forms of international conflict between these two uneasy neighbors that has included international war, major loss of landholdings following Mexico's defeat, and continuous exploitation of Mexican labor. Such employment is highly in evidence today in the millions of Mexican labor migrants supplying *essential* labor to billion-dollar American corporations, industries, and work sectors: agricultural farm work, fishing and forestry jobs, day labor, construction, landscaping and gardening, meat packing and poultry production, domestic cleaning, child and elderly care, hotel and office building janitorial services, and the vast service sector. It had been estimated that there were more than 9 million undocumented immigrants in the United States, with Latinos comprising more than 80 percent.[1] With about two-thirds

of these immigrants working, they constituted about 5 percent of the U.S. workforce. The Pew Hispanic Center estimates that the undocumented population has increased to between 11.5 and 12 million as of March 2006.[2]

To truly comprehend the precarious plight and fight of farm workers today, so vividly depicted in this book of photography, is to understand strained U.S.-Mexico relations beginning with America's westward expansion during the early 1800s, a direct encounter with a Mexico that once included today's southwestern United States. During the 1820s, the Mexican government offered American settlers tracts of land to homestead and develop on the condition that they respect Mexican law and eventually become Mexican citizens.[3] While some settlers complied, most did not and entered Mexico illegally, an interesting historical footnote given today's widespread resentment of undocumented Mexicans in the United States.

The War with Mexico. The popular new saying that "People don't cross borders, borders cross people" could not be truer for old Mexico, which was easily able to win the infamous battle of the Alamo in 1836, when American settlers claimed Mexican

land as their own Republic of Texas. Mexico lost the ensuing war with the United States, half its land, and as many as a hundred thousand Mexicans who instantly became American citizens by default, minus property protection.[4] As a bitter, defeated neighbor, Mexico has never recognized the moral right of the United States to Mexican land. As late as the 1940s, maps were still used in Mexican schools that designated northern Mexico as "territory temporarily in the hands of the United States."[5]

Mexican Labor Migration
in the Twentieth Century and Beyond

A decade-by-decade analysis of Mexican labor migration in the twentieth century reveals a clear cyclical pattern of exploiting Mexican workers during huge U.S. labor shortages followed by abusing their human and civil rights during periods of diminished labor need and economic recession. The following is based on a variety of historical, sociological, and ethnic studies works, including Acuña;[6] Massey, Durand, and Malone;[7] McWilliams;[8] Marger;[9] and McLemore, Romo, and González Baker.[10]

1910s: U.S. federal authorities waived immigration restrictions for Mexico during the World War I labor shortage in agriculture, allowing some seventy thousand Mexicans to enter the United States. These and other Mexicans were also pushed north by the bloody decade of the Mexican Revolution (1910 to 1920).

1920s: Improved canning and shipping technologies opened new markets during the 1920s, and about half a million Mexicans were pulled to work with little if any concern about their documentation status. While the Immigration Act of 1924 barred most southern and eastern Europeans, Mexicans were again exempted because they comprised the main source of cheap labor to industries essential to the development of the southwestern and midwestern United States (i.e., agriculture, mining, and railroads).

1930s: When the Great Depression hit in 1929, undocumented immigration to the United States was made a felony with massive deportation campaigns initiated against Mexicans, who were scapegoated for our country's economic problems. U.S. authorities either deported or coerced to leave an estimated half a million, or 40 percent of the Mexican-American population, in a program called repatriation, regardless of documentation status.

1940s: Despite the bad blood of 1930s, when the World War II labor shortage struck in 1942, the United States initiated a binational agreement with Mexico to import agricultural labor. From 1942 to 1964, the Bracero Program brought in an estimated 5 million braceros to work in the fields (bracero meaning "arm," or a loose translation of "workhand"). The Bracero Program also stimulated a parallel stream of undocumented workers who were extremely desirable to employers wishing to avoid the Bracero Program's bureaucratic red tape that included stipulations of fair pay and treatment of Mexican workers.

1950s: McCarthy era fear of Communists resulted in border control in the name of national security and the initiation of Operation

Wetback in 1954 that resulted in the deportation of an estimated eighty thousand Mexicans, with perhaps ten times as many fleeing to Mexico to avoid apprehension. As in the 1930s, the civil rights of Mexican-Americans were frequently violated as homes and businesses were raided for suspected illegal aliens. Yet during this same period, as many as 1 million deported Mexicans were delivered to the Department of Labor, quickly processed as braceros, and returned to the very farms from which they were deported, pleasing both growers and a hoodwinked public.

1960s–70s: Mexico halted the Bracero Program in 1964 because of mistreatment of Mexican laborers in Texas, the same year the United States extended strict immigration quotas to Mexico for the first time (only 120,000 per year). Thus began a twenty-year period of highly undocumented Mexican labor migration, given accelerating need for cheap labor in the United States and a lack of consequences for hiring undocumented workers despite increasingly restrictive immigration policies. The result was essentially an informal Bracero Program. Today a mere five thousand visas are available each year to unskilled laborers.

1980s: Mexico's economic collapse during what was called the "lost decade" exacerbated out-migration to the United States. Mexico had overinvested in oil infrastructure, having discovered vast oil reserves, resulting in bankruptcy when the price of oil plummeted on the international market. Unable to pay its foreign debt to the United States, Mexico agreed to U.S. requests to lift trade taxes and tariffs, paving the way for free trade. Meanwhile,

A trailer that once transported farm workers decays
behind a farm worker camp, Piru

the United States passed the Immigration Reform and Control Act of 1986 granting amnesty to almost 2 million undocumented migrants and posting major fines for hiring the undocumented. The new hiring law was never enforced, however, partly because of the rise of false documents, and hundreds of thousands of legalized farm workers fled the fields in search of better jobs, replaced instantly by a new crop of highly undocumented workers.

1990s: During this pivotal decade, all the above questionable labor and immigration policies culminated in an astounding contradiction: Formalized economic integration between the United States and Mexico, with the signing of the North American Free Trade

Agreement (NAFTA), yet increased immigration restriction as exemplified in 1994's Operation Gatekeeper, which militarized the border and erected a fourteen-mile-long steel fence in California. This "open border" policy for trade and "closed border" policy for immigration cannot coexist without facilitating undocumented migration, however, because NAFTA has increased U.S.-Mexico trade tenfold, and thus the number of business-related border crossings, creating a parallel stream of undocumented crossings, especially because U.S. investments in Mexico frequently displace workers and close down local businesses. While Operation Gatekeeper has done little to decrease illegal migration, it has made it more dangerous than ever to cross the border, as sadly evident by far more than 2000 crossing deaths since 1994, or about 150 to 200 each year.

The poignant picture worth a thousand words on the lethality of border crossing, contained herein, highlights a lonely pauper's grave on North American soil, impersonally marked "Jane Doe," yet adorned with a homemade cross, declaring No Olvidado, or Not Forgotten, as well as a Day of the Dead offering of food, drink, and affection.

Background Characteristics of Today's Farm Workers

While it is challenging to compile good data on predominantly undocumented and frequently mobile workers trying keep a low profile, the annual National Agricultural Workers Survey (NAWS), which the U.S. Department of Labor sponsors, reported in 2005 that approximately 75 percent of the country's 3 to 4 million farm workers are of Mexican origin, with increasing numbers of Central

Americans (2 percent), and a small but growing number of indigenous people from tribes such as Zapotec, Maya, and Triqui.[11] In California alone there are approximately 1 million mostly Mexican farm workers who provide the backbone to a yearly 32-billion-dollar agricultural industry. Try to imagine the world famous California wine industry without farm workers to pick grapes, the super cash crop that refuses to be picked by machine.

The closest thing to slavery? In May 2005, Mexican Pres. Vicente Fox got into cultural sensitivity trouble when, while addressing a group of Texas businessmen in Mexico, he said that "there is no doubt that Mexicans, filled with dignity, willingness, and ability to work, are doing jobs that not even blacks want to do there in the United States." Mexico's newfound love for its labor migrants, historically a source of embarrassment, is no doubt the result of the more than $20 billion in *migra-dollars* they send back in remittances each year, the country's second largest source of income (the Mexican government's official estimates are based on Banco de México databases of monthly transfers, reported to be just over $23 billion for 2006).

While black leaders were understandably quick to criticize Fox (Jesse Jackson labeling the remark "a spurious comparison" with "ominous racial overtones" and the Reverend Al Sharpton, Jr. calling it "insulting") it is interesting to note that the minister, Louis Farrakhan, publicly agreed with Fox, asking a crowd during an appearance at Mercy Memorial Baptist Church, "Why are you so foolishly sensitive when somebody is telling you the truth?" He then went on to say that blacks do not want to go to California to pick fruit because they already "picked enough cotton." Farrakhan's

not so subtle comparison of contemporary farm work to slavery is thought provoking in view of the litany of undesirable characteristics that describe this unique form of work in America.

The working poor. Today farm workers are among the poorest; most exploited; and most legally, socially, and geographically marginalized workers in America. Although they are part of a century-old tradition of supplying essential labor-intensive work to extremely profitable industries and corporations, they struggle and toil at the bottom of the U.S. stratification system, where they are very vulnerable to numerous life compromising problems and circumstances and a relentlessly hostile political environment.

As shown in table 1, the NAWS continues to document a migrant labor force that is predominantly Mexican, male, foreign-born, non-English-speaking, poor, of very low educational background, and more than 50 percent undocumented. Such background characteristics negatively interact with an unhealthy labor system to create risk for numerous psychosocial and health problems.

The Migrant Farm Worker Health Crisis

Death and injury. A pervasive health crisis has historically plagued farm workers in a wide variety of disturbing ways. For example, in the late 1980s, agricultural labor surpassed mining for the first time as the nation's most hazardous occupation with a record setting seventeen hundred deaths.[13] While mining may now have reclaimed its unwanted place as the most dangerous job in America, farm work consistently remains in the top two or three. For example, according to Schenker, work-related fatalities from agricultural labor were four times higher than in all other American

Table 1. Background Characteristics of Migrant Farm Workers in the United States

Population estimates	2.7 to 4 million
Foreign born	78%
Race/Ethnic background	
Mexican	75%
Other Latino	02%
White	20%
African American	02%
Other	01%
Gender (% male)	80%
Married	58%
Undocumented	53%
Education (average years)	07
Income (< $20,000 annually)	88%
Health insurance	23%
Poverty	30%
Illiteracy estimate	10%

Source: U.S. Department of Labor (2005)[12]

industries *combined* during the late 1990s.[14] Further, work-related deaths and injuries have not declined during the past fifty years as they have for all other American industries, including construction, with the possible exception of mining, given recent tragedies. Schenker notes that in California alone there are an estimated twenty thousand disabling injuries every year, yet two-thirds of

Table 2. Health Crisis Among Migrant Farm Workers

Work-related deaths and injuries
 Muscular-skeletal sprains and strains (e.g., back pain)
 Falls from ladders
 Machine-related accidents (lacerations, crush injuries, amputations)
 Electrocution
 Transportation accidents
Acute and chronic pesticide exposures and health consequences
 Eye problems
 Dermatitis
 Respiratory problems
 Cancer (e.g., lymphoma, brain tumors)
 Birth defects (e.g., limb reduction)
Chronic and infectious diseases
 Diabetes
 Hypertension
 Obesity
 Tuberculosis
 Alcoholism (in males)
 STDs including HIV/AIDS
Lack of field sanitation
 31% without toilet & water

Sources: Napolitano and Goldberg;[16] Rust;[17] Slesinger.[18]

farmers surveyed believe that farm work is less dangerous than other occupations.[15]

As can be seen in table 2, the pattern of more typical occupational injuries and illnesses affecting farm workers includes numerous work-related sprains, strains, and accidents; illnesses from acute and chronic pesticide exposure; and several related chronic and infectious diseases ranging from tuberculosis and diabetes to STDs, including HIV/AIDS. In fact, in 1997 researchers at the California Institute for Rural Studies published a pair of landmark studies on farm worker health that presented the first ever California statewide survey to include a comprehensive physical examination, and a national health survey of agricultural workers in Mexico and the United States. In the California survey, it was found that risk for chronic diseases such as heart disease, stroke, asthma, and diabetes were alarmingly high for a group of mostly young Mexican men who should be in top physical condition.[19] Similar results were found in the binational U.S.-Mexico survey with the additional finding that farm workers receive few, inconsistent, and uncoordinated services on *both sides of the border*, thus limiting chances for disease prevention with this unique population.[20]

Underutilization of health and human services. Despite harsh economic and health profiles, almost 80 percent of farm workers lack health insurance. Only 15 percent use safety net services such as Medicaid, while 11 percent use Women, Infants and Children (WIC), 8 percent use food stamps, and less than 1 percent use Temporary Assistance to Needy Families (TANF), according to the NAWS.[21] Such low rates of social services and government program use are the result of a formidable array of structural, cultural, and

legal barriers about which service providers need to be aware if they are to have any success serving farm workers.

The cost-benefit analysis of migrant labor in America. What the above rates of underutilization help make visible are the many holes in the inflammatory arguments of politicians and citizen groups claiming that the undocumented are an economic drain on public services and taxpayers. Such ongoing arguments typically fail to mention things such as the nearly $200 billion in unclaimed Social Security taxes steadily accruing in the U.S. Treasury[22] or the recent "Open Letter to President Bush and Congress" signed by more than five hundred economists, including five Nobel Prize winners, who argue that not only is immigration a net economic gain for the United States and its citizens, but it is also the "greatest anti-poverty program ever devised."[23]

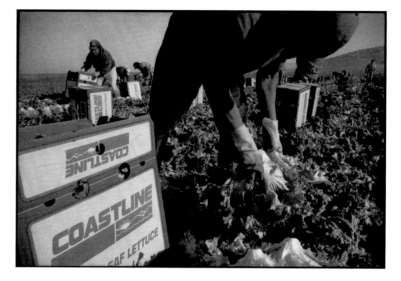

Lettuce workers, Salinas

Falling Through Legal Loopholes

Lack of protective bargaining. The problematic profile of farm workers above is rooted in their exclusion from major federal and state laws designed to protect the health, safety, and economic well-being of American workers. For example, while the National Labor Relations Act of 1935 was enacted to guarantee American workers the right to collective bargaining and to form unions, it explicitly excluded agricultural laborers.[24] Only in California have farm workers won the right to unionize thanks to the unprecedented grassroots efforts of Cesar Chavez and Dolores Huerta who founded the United Farm Workers (UFW) back in the 1960s.

Child labor. The Fair Labor Standards Act of 1938 essentially legitimized farm worker poverty and facilitated migrant child labor.

This act, which regulates minimum wage, time and a half pay for overtime, and child labor, has never been equally applied to farm workers.[25] As a result, farm workers have historically been paid less than minimum wage, denied overtime pay, and an estimated one hundred thousand children perform farm labor at ages younger than their American counterparts.[26] For example, the minimum age at which children in the United States can work nonhazardous jobs is fourteen to sixteen years, yet twelve-year-old children are permitted to perform hazardous farm labor, outside of school hours, with parental consent. Such differential applications of the law probably contribute to roughly three hundred deaths annually of children and adolescents as a result of farm injuries.[27]

The employer shell game. At the state level, so-called labor contractors, who provide work crews to growers, are increasingly recognized as the legal employers of farm workers. This clever arrangement dismisses growers from legal employer-related responsibilities to workers while leaving farm workers vulnerable to frequently unscrupulous contractors who overcharge them for substandard housing and dangerous transportation and sometimes cheat them out of hard-earned pay.[28]

Not even OSHA protection? Surprisingly even the Occupational Safety and Health Act (OSHA) of 1970, which mandates and regulates health and safety work standards, excludes farm workers.[29] One result of this arrangement is drastic disparities in federal spending on farm worker health and safety. For instance, while the federal government spent just under two hundred dollars per miner in 1985 to ensure health and safety, it spent only thirty cents per agricultural worker.[30] Further, a U.S. Department of Labor study conducted in the early 1980s found that only 1 percent of OSHA inspections were performed in agricultural work settings.[31]

Another result of the above arrangement is the major health problem of pesticide exposure, with the Environmental Protection Agency (EPA) lacking the teeth necessary to protect human health and the environment: while the EPA issues standards of pesticide protection for farm workers, there is no formal regulation of such standards nor any mechanism for reporting violations despite EPA estimates of three hundred thousand acute pesticide exposures annually in farm labor.[32] The fact that congressional oversight of pesticide laws are under the control of House and Senate agricultural committees, and not environmental, health, and labor

committees, creates a conflict of interest pitting profits against farm worker health and the environment.[33]

The Need for Agricultural Labor Reform

Rather than regulating farm labor in America, Congress has historically chosen to address farm worker needs and problems by developing various federally funded assistance programs. While national programs such as migrant health, migrant education, migrant Head Start, and migrant job training sound appealing, each is operated by a different branch of the government, such as the Departments of Health, Education, and Labor, resulting in a lack of coordination and numerous gaps and duplications in farm worker services.[34]

The fact of the matter is that government assistance programs cannot begin to compensate for the lack of farm worker protection under existing labor and immigration laws. A significant part of the problem is that migrant government programs were never designed to remedy farm worker problems. They were intended as short-term strategies to assist farm workers until they were eventually displaced by mechanization somewhere during the 1970s. Obviously displacement never happened in major areas of agriculture (e.g., delicate cash crops such as grapes, berries, mushrooms, and flowers), and farm worker needs and problems continue unabated. For example, in 1962 the Migrant Health Care Act was passed to improve health care access for labor migrants by creating a national network of about four hundred federally funded clinics. Today these clinics reach less than 20 percent of migrant laborers.[35] In addition to the scarcity of such clinics, other barriers to health care include farm labor work schedules, lack of sick leave

and transportation, frequent geographical mobility, scarce bilingual services, and high rates of ineligibility because of the lack of documentation, and policies insensitive to farm work.

Farm Worker Agency and Activism

If you thought this essay was going to be a mini *Harvest of Shame* type portrayal of the helpless victims of large economic and political dehumanizing systems, you were only *half right*. The other half of the story is that there has been and continues to be a prideful agency and activism on the part of farm workers, labor migrants in general, and allies aimed squarely at urgently needed labor and immigration reform and ultimately human rights. For example, during the 1960s and 1970s, the UFW accomplished the seemingly impossible task of unionizing farm workers and winning collective bargaining rights in California in 1975 with the passage of the Agricultural Labor Relations Act (ALRA), resulting in unprecedented gains in fair labor contracts complete with health plans. Unfortunately, a dramatic reversal in ALRA enforcement resulted from the change in governorship from liberal Democrat Jerry Brown to conservative Republican George Deukmejian in 1983.[36] Deukmejian, who opposed farm worker unions and campaigned with heavy contributions from agricultural corporations, immediately slashed the ALRA budget and appointed progrower personnel to the ALRA enforcement board. Internal problems within the UFW, growing pains of such a young and unique organization, did not help matters.

Fortunately, farm worker resilience is exemplified by UFW cofounder Dolores Huerta, who remains active with the union, providing a wide variety of basic health and human services including housing for farm workers. She also recently began her own Dolores Huerta Foundation in 2002 dedicated to community organizing and leadership training in low-income communities and currently serves on the Board of Regents of the University of California.

The agency and activism of labor migrants was also highly in evidence when Congress recently drafted a bill to make it a federal crime or felony to be undocumented in the United States, and thus forever ineligible for citizenship. This time, however, unlike in the 1930s, millions of undocumented Latino workers and supporters organized themselves at the grassroots level to publicly contest this latest historical wave of anti-immigrant, anti-Latino rhetoric bathed in national security and border-control language reminiscent of the 1950s. The bill, sponsored by Senator James Sensenbrenner of Wisconsin (ironically, a state that has historically benefited tremendously from farm workers), also advocates making it a felony for anyone, including church clergy and social service providers, to provide assistance to undocumented people in need. No wonder the Catholic Church publicly declared the bill a human rights violation. And so the massive, national, peaceful, and patriotic demonstration of May 1, 2006, on the part of millions of labor migrants across American small towns and major urban centers signifies an enhanced expression of courage, political savvy, and refusal to be scapegoated, criminalized, and ultimately dehumanized.

It is this very spirit of human self-affirmation that Rick Nahmias is able to capture in this book, portraits of irrepressible pride in self-in-work, in being capaz, or capable of providing for one's family, future,

country of origin, as well as the United States. It is an old story worth retelling over and over, in both text and pictures, in the endless need to reaffirm our common origins, destiny, and humanity.

DR. KURT C. ORGANISTA is professor of social welfare at the University of California, Berkeley. He conducts research in the areas of HIV and AIDS prevention with Mexican/Latino migrant laborers and the treatment of depression in Latinos. He currently serves on the editorial boards of the *Journal of Ethnic and Cultural Diversity in Social Work, Hispanic Journal of the Behavioral Sciences,* and the *American Journal of Community Psychology*.

Notes

1. Jeffrey S. Passel, E. Passel, Randy Capps, and M. Fix, "Undocumented Immigrants: Facts and Figures" (Washington DC: Urban Institute Immigration Studies, 2004), 1–4.

2. Jeffrey S. Passel, *Size and Characteristics of the Unauthorized Migrant Population in the U.S.* (Washington, DC: Pew Hispanic Center, 2006), 1–2.

3. Rodolfo Acuña, *Occupied America*, 2nd ed. (New York: Harper and Row, 1981), 9–33.

4. S. Dale McLemore, Harriet Romo, and Susan González Baker, "Mexican Americans: From Colonized Minority to Political Activists," in *Racial and Ethnic Relations in America* (Boston: Allyn & Bacon, 2001), 187–220.

5. Carey McWilliams, *North from Mexico: The Spanish-Speaking People of the United States* (New York: Greenwood Press, 1968), 103.

6. Acuña, *Occupied America*.

7. Douglas Massey, Jorge Durand, and Nolan J. Malone, *Beyond Smoke and Mirrors: Mexican Immigration in an Era of Free Trade* (New York: Russell Sage Foundation, 2002).

8. McWilliams, *North from Mexico*.

9. Martin N. Marger, "Hispanic Americans," in *Race and Ethnic Relations: American and Global Perspectives*, ed. Martin N. Marger, 282–321, 5th ed. (Belmont, CA: Wadsworth Publishing Company, 2000).

10. McLemore, Romo, and González Baker, "Mexican Americans: From Colonized Minority to Political Activists."

11. U.S. Department of Labor, "Finding from the National Agricultural Workers Survey (NAWS) 2001–2002: A Demographic and Employment Profile of United States Farm Workers," research report no. 9 (Washington, DC: U.S. Department of Labor, 2005), 1–80.

12. U.S. Department of Labor, "Finding from the National Agricultural Workers Survey (NAWS) 2001–2002," 1–80.

13. George S. Rust, "Health Status of Migrant Farm Workers: A Literature Review & Commentary," *American Journal of Public Health* 80, no. 10 (1990): 1213–17. Marie Napolitano and Bruce Goldberg, "Migrant Health," in *Handbook of Immigrant Health*, ed. S. Loue, 261–76 (New York: Plenum Press, 1998).

14. Marc B. Schenker, "Preventive Medicine and Health Promotion are Overdue in the Agricultural Work Place," *Journal of Public Health Policy* 17, no. 3 (1996): 275–303.

15. Schenker, "Preventive Medicine and Health Promotion are Overdue in the Agricultural Work Place," 275–303.

16. Napolitano and Goldberg, "Migrant Health," 261–76.

17. Rust, "Health Status of Migrant Farm Workers," 1213–17.

18. Doris O. Slesinger, "Health Status & Needs of Migrant Farm Workers in the United States: A Literature Review," *The Journal of Rural Health* 8, no. 3 (1992): 227–34.

19. Richard Mines, Susan Gabbard, and Anne Steirman, "A Profile of U.S. Farmworkers: Demographics, Household Composition, Income and Use of Services," research report no. 6, prepared for the Commission on Immigration Reform (Washington, DC: Office of Program Economics, Office of the Assistant Secretary for Policy, U.S. Department of Labor, 1997), 1–38.

20. Richard Mines, Nancy Mullenax, and Lisette Saca, "The Binational Farm Worker Health Survey: An In-Depth Study of Agricultural Worker Health in Mexico and the United States" (Davis: California Institute for Rural Studies, 2000), 1–29.

21. U.S. Department of Labor, "Finding from the National Agricultural Workers Survey (NAWS) 2001–2002," 180.

22. Lawrence Downes, "Talking Points: The Terrible, Horrible, Urgent National Disaster that Immigration Isn't," *New York Times*, June 20, 2006.

23. David Theroux, *Open Letter on Immigration* (Washington, DC: The Independent Institute, 2006), 1–7.

24. Marian Moses, "Farmworkers and Pesticides," in *Confronting Environmental Racism: Voices from The Grassroots*, ed. R. D. Bullard, 161–78 (Boston: South End Press, 1993).

25. Carol Sakala, "Migrant and Seasonal Farm Workers in the United States: A Review of Health Hazards, Status, and Policy," *International Migration Review* 21, no. 3 (1987): 659–87.

26. Slesinger, "Health Status & Needs of Migrant Farm Workers," 227–34.

27. Schenker, "Preventive Medicine and Health Promotion are Overdue," 275–303.

28. Moses, "Farmworkers and Pesticides," 161–78.

29. Moses, "Farmworkers and Pesticides," 161–78.

30. Schenker, "Preventive Medicine and Health Promotion are Overdue," 275–303.

31. Sakala, "Migrant and Seasonal Farm Workers in the United States," 659–87.

32. Napolitano and Goldberg, "Migrant Health," 261–76.

33. Moses, "Farmworkers and Pesticides," 161–78.

34. P. L. Martin and D. A. Martin, *The Endless Quest: Helping America's Farm Workers* (Boulder, CO: Westview Press, 1994), 1–30.

35. Sonia Sandhaus, "Migrant Health: A Harvest of Poverty," *The American Journal of Nursing* 98, no. 9, 52–54.

36. Theo J. Majka and Linda C. Majka, "Decline of The Farm Labor Movement in California: Organizational Crisis and Political Change," *Critical Sociology* 19, no. 3 (1992): 3–36.

Migrant Farm Workers and the
Immigration Policy Controversy

Bruce Goldstein

Migrant farm workers in the United States have suffered from low wages and poor working conditions throughout the nation's history, and federal immigration policies have been at the core of farm workers' problems. In the United States today, more than 80 percent of farm workers are foreign-born.[1] America's laws on international labor migration have long been decided primarily on the claimed needs of agricultural employers for new supplies of foreign workers at wages and working conditions that most Americans, whether citizens or immigrants, will not accept. The specific immigration status, if any, under which farm workers are employed is often so restrictive that it ensures workers' economic and political weakness. In regulating job terms of migrant workers, the government has often impeded improvements in farm workers' wages and working conditions.

The nation's 2.5 million farm workers have exerted little influence over the economic activities and government policies that determine their living and working conditions.[2] Rarely have farm workers gained the economic clout with their employers to win substantial improvements in their wages and working conditions. Government policies still focus on corporate interests, and our labor-protective laws discriminate against farm workers based on their occupation. There have been major exceptions to these statements, especially in California, where about nine hundred thousand workers labor in the fields; however, few would contend that farm workers can live the American dream by remaining in farm work.[3]

There is some justification for believing that America's farm workers can play a larger role in the forces that have controlled their lives and especially in the future of immigration policy. While the problems are quite complex and controversial, and farm workers still lack enough power to win ideal solutions, the potential exists for achieving compromises that are fair and sensible.

The Farm Worker Problem

Daniel Rothenberg in *With These Hands*, his fine history of current-day farm workers, writes: "The key components of the farm labor system have been a steady oversupply of workers and the use of a series of techniques to consistently disempower farm workers."[4]

Agricultural employers have used their considerable political and economic advantages to win government policies that ensure new flows of citizens from poor nations who are desperate for low-skilled jobs in the United States. Ordinarily they do not come

in as immigrants because immigration visas are not made available for them. Undocumented workers come into the United States in large numbers, with little immigration enforcement to stop them from working in America's fields. Congress also has enacted "guest worker" programs, like the Bracero Program from 1942 to 1964, and the current H-2A agricultural guest worker program. Guest worker programs allow employers to bring in foreign workers on temporary, nonimmigrant work visas on the condition that they return to their homelands at the end of the job. The guest workers are vulnerable to abuse because they are tied to their employer while in the United States and are dependent on the employer to obtain a visa for them in future years. They usually are too fearful of being fired and deported to challenge illegal or unfair employer conduct. When guest workers or undocumented workers are available to fill jobs, U.S. citizens and authorized immigrants have little bargaining power with their employers.

All farm workers, regardless of immigration status, have suffered from discriminatory labor laws.[5] The growers have exercised political power to ensure that they need not comply with labor protections that apply to virtually all other occupations. Farm workers are still excluded from overtime pay rules. The National Labor Relations Act, which protects employees against retaliation for organizing a labor union, excludes farm workers. Health and safety protections applicable to other occupations do not cover farm workers. Children may work in agricultural jobs that are labeled "hazardous" even though they are prohibited from performing such work when it occurs in another industry.

For those labor protections that do apply, labor law enforcement, like immigration law enforcement, has been utterly inadequate. Most employers are willing to take the risk of violating the law. Many growers deny that they "employ" any farm workers and claim that a farm labor contractor is the sole "employer" for purposes of the minimum wage and other laws. Few private lawyers will take farm worker wage cases because there is not enough money involved to justify the expense. Federally funded legal aid programs have had their budgets cut to the bone and are prohibited from representing most farm workers because they are undocumented.

These policies and practices have resulted in low wages, an absence of fringe benefits, dangerous working conditions, and a farm labor force that is predominantly undocumented and nonunion. Farm workers in the labor-intensive fruit and vegetable sector average between $10,000 and $12,500 per year in income.[6] Citizens and legal immigrants often face financial, geographic, legal, and other obstacles to obtaining government benefits, such as food stamps and subsidized housing, even when they are available, and undocumented workers are not eligible for such benefits.

Not surprisingly, many workers leave agriculture when they find other options. A Department of Labor study of seasonal farm workers employed on fruit and vegetables farms (about 1.6 million people) estimated that 1 in 10 (about 160,000) leave agriculture each year.[7] A more recent survey found that about 16 percent of people working on such farms had arrived in the United States for the first time within the one year before being interviewed.[8]

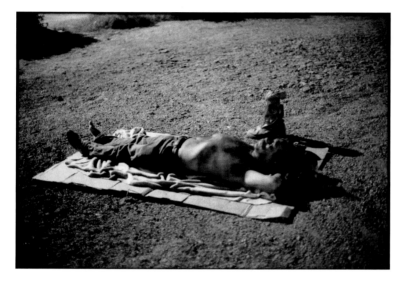

For nearly three months during the grapes harvest, this migrant sleeps
on a cardboard mat in a dirt lot, Mecca

Turnover seems to have increased. Most farm workers now lack authorized immigration status, and as the documented immigrants and citizens leave farm work, undocumented workers are taking their place.[9]

Agribusiness has achieved a self-fulfilling prophecy: "No Americans want to take our jobs." America's agricultural labor shortage is perpetual, if the employers are to be believed. In 1951, the President's Commission on Migratory Labor, a blue-ribbon panel, concluded that the growers' claims of that time were "almost identical with those of 40 years earlier." The 1909 Country Life Commission had informed Pres. Theodore Roosevelt that "there is

a growing tendency to rely on foreigners for the farm labor supply . . . It is the general testimony that the native American labor is less efficient and less reliable than much of the foreign labor."[10] Almost one hundred years later, growers are still claiming that they cannot find enough reliable workers inside our borders.

When the evidence demonstrates an adequate supply of farm labor, the growers argue that severe shortages are imminent and they can do nothing to prevent them. The Commission on Agricultural Workers, which Congress created to monitor the 1986 immigration law, issued a report in 1992 concluding that there was no agricultural labor shortage and rejected the need for a new guest worker program. The 1986 immigration law had legalized the status of almost 1.1 million formerly undocumented workers. Commission member Michael Durando, then the president of the California Grape and Tree Fruit League, issued a supplemental opinion, stating that the number of undocumented farm workers was increasing and Congress might spend more money enforcing immigration laws. Mr. Durando went on to say, "Should this occur, the Commission's own evidence suggests that a massive worker shortage would develop. . . ."[11] Just three years later, agribusiness began lobbying vigorously for a new guest worker program.

A Long History of Sensible Solutions Ignored

Objective analysts have repeatedly responded to the employers' incessant claims of labor shortages with the same answer: stabilize the farm work force by improving jobs terms and government labor protections. The President's Commission on Migratory Labor

in 1951 said that its conclusion reiterated the 1909 report of the Commission on Country Life. "Farm employers of migratory labor . . . continue to offer jobs and working conditions that are no better and in many respects are worse than those offered three and four decades ago. Having failed to move forward on employment standards and finding that domestic labor does not respond readily to the working conditions offered, farm employers now ask for foreign laborers willing to accept the low standards they offer, or who are compelled to do so by 'dire necessity,' to use the words of the Country Life Commission of 40 years ago."[12]

The 1951 commission, echoing the earlier report, challenged America to "create honest-to-goodness jobs which will offer a decent living so that domestic workers, without being forced by dire necessity, will be willing to stay in agriculture and become a dependable labor supply."[13] The 1992 Report of the Commission on Agricultural Workers reached the same conclusion even though six of the eleven commission members were agribusiness representatives and only one was a farm worker representative. Noting that farm workers had experienced stagnant or deteriorating wages and working conditions, the commission concluded that "agriculture must improve its labor management practices," "modernize to remain successful in the increasingly competitive marketplace," and take other steps "to stabilize the labor force."

The 1951 presidential commission report said, "Unfortunately, the advice of that Commission has not been heeded," referring to the impact of the 1909 commission. The same can be said about the impact of the 1992 commission report.

There have been improvements in government policy since 1909. In 1966, Congress extended coverage of farm workers under the minimum wage (but not overtime) provisions of the Fair Labor Standards Act. In 1982, Congress replaced an earlier, ineffective law with the Migrant and Seasonal Agricultural Worker Protection Act (AWPA), a wage-hour law that also regulates the use of farm labor contractors, housing, and transportation safety. In 1987, a lawsuit forced the Department of Labor to issue a regulation requiring larger growers to provide farm workers with toilets, hand-washing water, and drinking water in the fields. In 1992, the Environmental Protection Agency strengthened its Worker Protection Standard regarding farm workers' exposure to toxic pesticides. California, in response to the organizing of the United Farm Workers during the 1960s and 1970s, passed an agricultural collective bargaining law, extended overtime to some farm workers, and generally provides stronger labor protections than anywhere else in the country.

The primary mechanism by which farm workers have achieved their greatest advances has been union organizing. After the end of the bracero guest worker program in 1964, Cesar Chavez, Dolores Huerta, and the organization that became the United Farm Workers won collective bargaining agreements that increased wages substantially, granted fringe benefits for the first time, and created grievance-arbitration procedures to protect against unfair treatment on the job. Their labor organizing also led to political power, especially in the California legislature. In the Midwest, the Farm Labor Organizing Committee during the 1970s and 1980s successfully brought public pressure to bear on food producers to negotiate with the union and with the

growers who employed cucumber and tomato workers, leading to innovative collective bargaining agreements and a unique private commission that continues to resolve disputes and has been extended to North Carolina. These and other farm worker unions have remained active and won important victories in recent years.

These important advances have not gone far enough to prevent instability in the farm labor supply. As described above, farm workers still experience discrimination in labor laws and utterly inadequate labor law enforcement has meant that employers do not fear violating the law. The federal minimum wage remained stuck at $5.15 per hour for ten years beginning in 1997. Growers increasingly used labor contractors, many times in an effort to shift responsibility for compliance with labor laws and lower their labor costs by paying less than the law requires. Farm workers' low wages have prevented them from creating a housing market to meet their needs, and federal funds for subsidized housing, which are inadequate, cannot be used for undocumented farm workers; many live in dangerous conditions.

The stronger sanctions enacted in 1986 against employing unauthorized immigrants were never enforced effectively. Agricultural employers have had easy access to undocumented workers from Mexico and other countries. When the labor supply is readily available, employers need not compete strenuously for workers. When most of the labor supply is undocumented, the workers' bargaining power is especially weakened. There is no doubt that the farm labor union movement has been hurt in recent years by the presence of so many undocumented workers whose lack of immigration status causes most of them to fear being fired and deported if they organize labor unions or otherwise challenge employer conduct.

The Battle Over the Labor Supply: Immigration and Labor Policy Debates

Beginning in the mid-1990s, Congress engaged in a contentious debate about immigration policy for the agricultural sector. In some ways, not much about this debate differs from previous ones. For the first time, however, farm worker organizations, led by the United Farm Workers, gained a seat at the negotiating table regarding immigration and labor policy.

The Nature of Guest Worker Programs

To help explain this important debate, we briefly summarize the recent history of agricultural guest worker programs.

The Bracero Program began during World War II to respond to alleged wartime labor shortages. It started small but grew to four hundred thousand visas per year at its peak. A total of about five million jobs were filled by Mexican citizens by the time the Bracero Program ended in 1964.[14] The Bracero Program evolved over time, but generally was based on a federal law and a U.S.-Mexico government-to-government agreement that regulated recruitment and job terms. Despite its notoriety for abuse the Bracero Program did contain labor protections. Under the Bracero Program, the labor secretary had to certify that: There was a labor shortage requiring use of braceros; employment of braceros would not adversely affect the wages and working conditions of

domestic agricultural workers similarly employed; and reasonable efforts were made by employers to attract domestic workers for employment offered to braceros.[15] Specific provisions addressed housing, insurance, wage protections, transportation cost reimbursement, employment guarantees, and job preference for U.S. workers.

The principal problem with the Bracero Program arose from the braceros' status as nonimmigrant "guest workers" who lacked economic or political bargaining power. Most guest workers were too fearful of losing the opportunity to work in the United States to challenge unfair or illegal conduct. They were dependent on employers to request a visa for them each season. Their wages stagnated and in real terms, decreased. As temporary workers on nonimmigrant visas with no path to citizenship, they had no political clout to win reforms the powerful agribusiness industry opposed. Politicians had no need to respond to workers who would never get the right to vote in American elections. After years of controversy and the expansion of the civil rights movement, the Bracero Program finally ended in 1964.[16]

The H-2 guest worker program began in 1943 when the Florida sugar industry, which hired thousands of seasonal sugarcane cutters, obtained permission to hire Caribbean workers on nonimmigrant temporary work visas. The H-2 program was not part of an international agreement, although Caribbean nations formed a consortium, the West Indies Central Labor Organization, to monitor and assist the program. The little-known H-2 program, named after a subsection of the immigration law, remained on the books after the Bracero Program ended. Although national

in scope, the H-2 program operated primarily on the east coast, especially in sugarcane, tobacco, and apples. In 1986, Congress divided the program into the H-2A program for seasonal agricultural jobs and the H-2B program for seasonal nonagricultural employment such as tourism and landscaping. The H-2A program has doubled in the last ten years to about forty-five thousand approved jobs but has remained a small portion of the overall farm labor force thus far. The program has been rife with abuses since its inception.[17]

Congress, in drafting the H-2 and the Bracero Program, evidenced its understanding of the risks of guest worker programs. The law's most basic protection prohibits employers from employing guest workers if to do so would "adversely affect" the wages or working conditions of U.S. workers. In the absence of such a standard, employers could offer very low wage rates that poverty-stricken workers in poorer nations would accept but no U.S. workers could afford to, and thereby create an artificial labor shortage. Such wage rates would not only cause displacement of U.S. workers but also depress the wage rates of U.S. workers who remained. Congress also understood that agricultural guest workers, coming from distant nations with few contacts in America, would need a place to live without burdening local communities, as well as transportation to leave the United States once the job ended (so that they did not remain illegally).

The H-2A program therefore requires employers to recruit workers inside the United States before seeking guest workers and offer certain minimum wages and benefits to demonstrate that the alleged labor shortage is bona fide. An employer

claiming a labor shortage must apply for a "labor certification" to the U.S. Department of Labor before it may arrange for visas for workers it recruits in a foreign country. The H-2A wage requirement, as a practical matter, is based primarily on regional wage surveys of nonsupervisory farm workers. The H-2A Adverse Effect Wage Rate (AEWR) varies by state but in recent years has been $2.00 per hour to almost $4.00 per hour above the stagnant federal minimum wage, which, until recently, was $5.15 per hour. The employers must also reimburse workers for their in-bound travel costs once half the season has elapsed and pay the workers' way home if they finish the season. If the Department of Labor concludes from the recruitment effort that the employer faces a shortage, the department gives the employer a "labor certification" with which the employer may arrange for temporary work visas for foreign citizens. Both U.S. workers and H-2A guest workers who are employed at an H-2A program employer are entitled to the minimum wages and benefits required by the law and regulations.

The H-2A visa allows the guest workers to work only for the employer that arranged the visa and must return home at the end of the season. It is a "nonimmigrant" visa. Guest workers may not switch employers although, under certain circumstances, H-2A employers may shift workers from one to another. A guest worker who seeks to return in a following year must hope that the employer requests a visa for him (almost all H-2A workers are men). Unlike most visas, the H-2A program, as a result of grower lobbying, has no maximum limit on the number of H-2A visas that may be issued each year. The program is unlimited. The H-2A workers never earn a right to enter the United

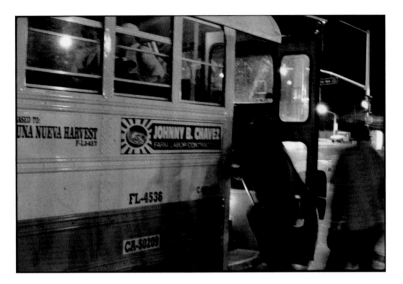

Migrants load buses before setting out to the fields, Calexico

States as immigrants, no matter how many years they return as guest workers.

Employers have complained that the H-2A requirements are onerous and that the Department of Labor does not adequately respond to their labor needs. They say that the incentives to hire undocumented workers outweigh the incentives to use the H-2A program. They argue that the program would be much larger if wages were lower and government oversight of the application were reduced.

Farm worker advocates have argued that the H-2A labor standards are inadequate; the department approves employers' applications that should be denied, the employers routinely violate

workers' rights, and DOL's enforcement is lax. They also contend that because undocumented workers are cheaper and immigration enforcement is weak, many employers choose not to use the H-2A program but could do so if they wished to.

The Debate Over Guest Worker Programs and Earned Legalization

During the 1990s Congress began debating immigration policy for agriculture but only fought to a stalemate. Farm worker advocates argued that guest worker programs are inherently abusive toward workers. They sought an immigration policy that provides undocumented workers presently in the United States and future farm workers from abroad with the opportunity to become legal immigrants. Congress, however, would not abolish the H-2A guest worker program. While many agricultural employers were willing to support the concept of a program to legalize their current undocumented work force, their main objective was removing the H-2A program's labor protections. The legislative reality is that for either side to achieve some of their major goals, they had to compromise and unite against congressional immigration-restrictionists who opposed all such policy proposals.

Legislators with close ties to agricultural employers repeatedly introduced bills to create a new agricultural guest worker program or substantially revise the H-2A program to make it enormously attractive to growers. These proposals were unacceptable to farm worker advocates because they would have slashed wages and benefits, minimized government oversight, and eliminated workers' chances to enforce the few rights that would have remained. The

proposed deregulation would have transformed the farm labor market into a guest worker system as massive as the Bracero Program.

These agribusiness-sponsored proposals, if successful, would have made the H-2A program worse than the Bracero Program by reducing substantive labor protections and government oversight. The Bracero Program required employers to abide by standard work contracts that were governed by the Migrant Labor Agreement of 1951 and negotiated by Mexico and the United States.[18] They included provisions addressing housing, health insurance, wage protections, transportation reimbursement, minimum employment guarantees, and domestic worker protection. The 1990s grower-endorsed guest worker programs provided few of these protections.

The growers came close to success in 1998 with the help of three senators with economic interests in farming: Gordon Smith (R-OR), Larry Craig (R-ID), and Bob Graham (D-FL). The Senate hastily passed a guest worker amendment as part of an appropriations bill, but, largely because of President Clinton's objections, it did not become law. Earlier, in 1996, agribusiness had obtained a vote on their guest worker proposal in the House of Representatives but lost 180–242.

Most farm worker advocates knew that the Republican-controlled House and Senate would not be willing to advance a profarm worker immigration bill. Farm workers and their allies had to play defense. Their success in defending against these proposals was aided by an unlikely source.

The profarm worker and proemployer factions were joined in the debate by a third group, immigration-restrictionists, most (but

not all) of whom were Republicans. These included Rep. James Sensenbrenner (R-WI), former chair of the House Judiciary Committee; former Rep. John Hostettler (R-IN), who chaired the immigration subcommittee; Rep. Tom Tancredo (R-CO); and Sen. Jeff Sessions (R-AL). This group wants to remove undocumented workers from the United States, actively enforce immigration laws, and substantially reduce the number of immigrants admitted to the United States. This group particularly opposes granting legal immigration status to undocumented workers, which they deride as "amnesty" for "illegal aliens." Some of the immigration-restrictionists say that they oppose employers' access to "cheap foreign labor" because they want to "protect American jobs," but most members of this group are conservatives who opposed raising the federal minimum wage and other labor protections. Many in this group do not favor guest worker programs because they oppose admitting new foreign citizens in any status and also fear that guest workers create new networks of migration among family members and neighbors.

As discussed further below, advocates of granting immigration status to undocumented farm workers responded to the "amnesty" objection by offering a compromise. The compromise would be referred to as "earned legalization" because the path to legal immigration status would not be automatic for any undocumented farm worker. Eligibility for immigration status would require proof of previous agricultural work experience in the United States and an obligation to continue to perform agricultural work for a specified period of time. Most farm worker advocates had opposed any prospective-work requirement as a form of involuntary servitude,

but the compromise began to seem a reasonable solution to a festering, untenable situation. Most of the restrictionists, despite having no meaningful solution, vigorously opposed the earned legalization concept.

The presence of the immigration-restrictionist faction split the traditional support in the Republican Party for agribusiness demands related to labor issues. During the 1990s, the growers sought to gain greater support among this third group for a new guest worker program by emphasizing the sharp restrictions on H-2A temporary visas and arguing that agriculture has unique needs because of the seasonality of the industry and the perishability of the produce. Still, the "purists" among the immigration-restrictionists did not want a new guest worker program or changes to the H-2A program that would substantially increase the number of guest workers.

This Republican opposition to the growers' guest worker proposals was useful to farm worker advocates in preventing passage of a harmful new program. It did not, however, add any support for farm workers' demands. These Republicans did not support more labor protections in the H-2A program, for example. Consequently, the key to progress seemed to require a compromise between labor and management that garnered enough bipartisan congressional support to outweigh the immigration-restrictionists.

The stalemate led to an unprecedented negotiation at the national level between farm worker union leaders and major agribusiness groups. Serious discussions about a possible compromise began at the end of the 106th Congress (1999–2000). For farm workers, the negotiations were led by Rep. Howard Berman (D-CA),

an expert and long-standing farm worker advocate, and the United Farm Workers union. The National Council of Agricultural Employers continued its long-standing leadership on labor and immigration issues for the labor-intensive agricultural sector, supported by Sen. Bob Graham (D-FL), Sen. Gordon Smith (R-OR), and Rep. Chris Cannon (R-UT) and, for a time, the American Farm Bureau Federation. Sen. Larry Craig (R-ID) eventually became the leading Republican proponent of the compromise. After lengthy, arduous negotiations, a delicate agreement was reached.

Summary of AgJOBS

The compromise became known as the Agricultural Job Opportunities, Benefits, and Security Act (AgJOBS). Proponents argued that it was a balanced solution after years of conflict that would stabilize the work force with legal workers; enable us to know who is working in our fields; ensure productive, safe agricultural production; and end years of conflict.

AgJOBS contains two parts, an earned legalization program and revisions to the H-2A guest worker program. The bill is complex and has evolved over time, but space only allows a brief summary.[19]

The earned legalization program contains two steps. First, a farm worker could apply for a special visa called a blue card denoting a temporary resident status. Undocumented workers and H-2A guest workers would be eligible for a blue card if they could demonstrate that they worked in U.S. agriculture for at least 150 days during the twenty-four-month period ending the year before the bill's enactment and were not disqualified based on criminal convictions or other grounds of inadmissibility under immigration law. The program is aimed at fruit, vegetable, livestock, dairy, and other employees on farms and ranches (not poultry processing or meat-packing plants). The application process was designed to recognize that undocumented workers would need some flexibility to prove their past employment, since they and their employers often were seeking to escape detection and actual employment records may be difficult to find. Blue-card holders could work in any occupation and could travel across our borders.

Second, the blue-card holder would need to perform additional agricultural work to earn permanent resident status, a green card. Simply stated, they could perform 100 work days per year for *five years* during the five-year period beginning on the date of enactment of the Act or 150 work days per year for *three years* during that five-year period. Failure to gain permanent status within seven years would require the worker to leave the country. Conviction of a felony; three misdemeanors; or a single crime involving bodily injury, threat of serious bodily injury, or injury to property in excess of five hundred dollars also would end the blue-card temporary status. It is not an easy program to satisfy. As many as 800,000 to 900,000 farm workers could be eligible based on estimates of the number who could qualify under the past-work requirement.

The immediate family members of the farm worker with a blue card would not be deported for being undocumented (absent other reasons to deport the person). Spouses could obtain a temporary work permit. Once the farm worker fulfilled the requirements to receive permanent resident status, spouses and minor children also would be granted immigration status as long as they meet other

requirements under immigration law. (Minor children who become adults during the process are covered, too.)

The compromise would modify the H-2A temporary foreign agricultural worker program, which allows agricultural employers to apply for permission to hire seasonal workers on temporary work visas. Most basic H-2A requirements that protect U.S. workers from adverse effects and foreign workers from exploitation would continue. The bills would modify some current H-2A requirements in the following important ways:

- The program's application process would be streamlined to become a "labor attestation" program, rather than a "labor certification" program. The attestation process reduces the paper work employers must file, shortens time frames between application and approval of the request for guest workers, and reduces government oversight during the application process (supposedly leaving the emphasis on stringent punishment of employers who violate their obligations to the workers).

- H-2A employers must provide free housing to nonlocal U.S. and foreign workers but, under AgJOBS, could choose to provide a monetary housing allowance if the state's governor has certified that there is sufficient farm-worker housing available in that area.

- Employers would still offer the highest of the AEWR, the prevailing wage, or the federal or state minimum wage. AgJOBS would reduce the H-2A AEWRs to those of several years ago and freeze them there for three years. During this three-year period, the congressional General Accountability Office (GAO) and a special commission would issue studies and recommendations as to the appropriate wage rate formula. If Congress fails to enact a new formula within three years after enactment, the AEWRs will be adjusted by the previous year's inflation in the consumer price index and annually thereafter, up to 4 percent per year.

- For the first time, H-2A workers could file a lawsuit under federal law in federal court to enforce their wages, housing benefits, transportation cost reimbursements, minimum-work guarantee, vehicle safety protections, and other job terms.

Legislative Efforts to Pass AgJOBS

Despite the compromise between traditional foes and the bipartisan support for it, AgJOBS has been controversial in Congress. Efforts were made to enact it in late 2000, at the end of the congressional session when the Bush-Gore election vote was undecided, but Republican leaders in the Senate blocked them. The compromise fell apart shortly after when Republicans gained control over the White House, and agribusiness thought it could win more concessions.

During the summer of 2001, there seemed to be progress in efforts to reach a broad compromise on immigration policy that

the White House and many members of Congress could accept. President Bush had expressed interest in a guest worker program with no path to citizenship, but some observers believed that, under the right circumstances, he would sign a bill that contained a broad legalization program. Progress ended suddenly with the terrorist attacks of September 11, 2001.

In September 2003, key members of Congress, agricultural employers, and farm worker advocates, led by the United Farm Workers, again reached another compromise on AgJOBS.

Serious efforts were made to pass the legislation. A strange-bedfellows alliance of farm worker, labor, civil rights, religious, Latino, and agricultural employer groups mounted a strong campaign around the country and in the halls of Congress that garnered supportive editorials from major newspapers. The goal was to pass the bill in the Senate to build momentum and then move to the House of Representatives, where immigration-restrictionists held key positions of power.

Opponents of AgJOBS offered alternatives, primarily with the goal of defeating it or else passing guest worker provisions that benefited agricultural employers but did not contain an earned legalization program for undocumented workers. Some proposals resembled the bills that the grower groups had sought unsuccessfully to pass in the 1990s. Some proposals were simpler, focused on lowering H-2A wage rates. The sponsors of these proposals included Rep. Robert Goodlatte (R-VA), a member of the anti-immigrant forces in Congress and chair of the House Agriculture Committee, and Sen. Saxby Chambliss (R-GA), who had been an attorney for H-2A program growers before entering

Congress. The national Farm Bureau withdrew its support for AgJOBS by 2006 and supported these proposals. Most labor-intensive agricultural producers, however, viewed AgJOBS as their only hope for relief.

One campaign, in April 2005, revealed the nature of the conflict over AgJOBS. During consideration of a supplemental appropriations bill for the Iraqi war (H.R. 1268) proponents sought to include AgJOBS as an amendment (no. 375). Sen. Jeff Sessions (R-AL) staunchly opposed AgJOBS, especially the legalization component, "because if you become a legal permanent resident, then you are no longer an indentured servant."[20] Sens. Saxby Chambliss (R-GA) and Jon Kyl (R-AZ) presented an alternative bill to AgJOBS (Sen. Am. no. 432), a harsh guest worker program with no opportunity for earned legalization and one-sided, employer-friendly changes to the H-2A program (similar to those proposals introduced during the late 1990s). Senator Kennedy said the Chambliss "program would return us to the dark and shameful era of the Bracero Program where abuses were rampant and widely tolerated. This is unacceptable. We must learn from our mistakes and not repeat them."[21] The Senate defeated the Chambliss alternative resoundingly, 77–21.

Senators voted 53–45 in favor of AgJOBS, a majority, but not the sixty votes needed to overcome a threatened filibuster. Several of those who voted against AgJOBS were cosponsors who apparently opposed adding a major immigration program to a military spending bill but could be expected to vote for AgJOBS in the future. Thus, AgJOBS had at least majority support and possibly as many as sixty votes at an appropriate time.

In May 2006, the Senate Judiciary Committee, led by Sen. Arlen Specter (R-PA), included AgJOBS in its comprehensive immigration bill (S.2611). By this time, Sen. Dianne Feinstein (D-CA), who earlier had opposed AgJOBS, had negotiated changes with Senators Kennedy and Craig that the union and grower groups accepted and became a leader of the legislative campaign. Having both California senators, Boxer and Feinstein, support AgJOBS sent a strong message that the compromise was important to California's 28-billion-dollar agricultural sector, the largest in the nation.

On the Senate floor, Senator Chambliss sought to eliminate the earned legalization program from the AgJOBS provisions in the comprehensive immigration bill. He also introduced an amendment to slash the H-2A wage rates; this amendment resembled legislation bills in the House by Robert Goodlatte (R-VA) and Lincoln Davis (D-TN). The Senate rejected both of Chambliss's amendments and passed the immigration bill with AgJOBS intact.

The House leadership, seeking to take a tough stand on immigration in the 2006 election campaign, refused to bring the Senate immigration bill or AgJOBS to a vote and the 109th Congress ended without action. Early in the 110th Congress, in January 2007, Senators Craig, Feinstein, and Kennedy introduced AgJOBS and announced their plans to seek a vote and passage. True to form, Sen. Chambliss sought to cut the H-2A program wage rates by adding an amendment to the Senate's legislation to raise the minimum wage. After it became clear that Chambliss would lose, he withdrew the amendment, and the minimum wage bill passed without it. AgJOBS supporters hoped to pass the bill (S.340, H.R. 371) in 2007, before the presidential election campaign politics made immigration policy too controversial for Congress to handle. The immigration-restrictionists, joined by several pro-labor senators who thought too many concessions had been granted, prevented the bill from moving forward. AgJOBS remained caught up in the controversies over the comprehensive immigration reform bill. The prospects for passing AgJOBS itself remained difficult.

Conclusion

Farm workers' experience has demonstrated that guest worker programs should not be the model for managing migration. Guest workers are routinely exploited. More important, guest worker programs do not ordinarily allow a path to citizenship. Instead, they create a pool of workers deprived of the right to vote or exercise the economic freedoms that we have justifiably come to expect. Our democratic traditions are undermined by guest worker programs. Immigration status should remain the primary model for managing migration. We disagree with Senator Sessions, who seemed to mourn the fact that the AgJOBS legalization program would prevent us from returning to an era of "indentured servants."

For farm workers, winning AgJOBS is critically important. Most farm workers lack authorized immigration status, earn very low incomes, and face dangerous working conditions. They need legal immigration status so they can come out of the shadows of their undocumented status and join forces with citizens and authorized immigrants to bargain for better wages and working conditions and demand improved government policies. It is unfortunate

that AgJOBS would not abolish the H-2A guest worker program. Congress should replace the H-2A program and other guest worker programs with a system that permits foreign workers to enter the United States when needed and earn permanent immigration status. Politically, that fight is not winnable at this time. AgJOBS is the right choice. If farm workers had not demonstrated a sincere willingness to compromise with their opponents, Congress already would have passed a harsh guest worker program for agriculture. AgJOBS contains some painful concessions, but it will create a much better future than the status quo for hundreds of thousands of farm workers and their family members for many years to come.

If a legalization program is enacted, government and employers should take steps to stabilize this newly legalized immigrant work force by making agricultural work more attractive and productive. Government commissions and other experts have been making this basic recommendation for one hundred years. With a large number of legal-immigrant farm workers in the country, there should be no need for H-2A guest workers for many years after the legalization program begins.

Once a legalization program takes effect, America's farm workers should be encouraged to exercise their new economic and political freedoms. We should help them organize labor unions and other organizations to bring about fundamental change in the fields and in farm worker communities. America should end an embarrassingly long era of mistreatment of farm workers and become a global leader in improving living and working conditions for agricultural workers.

BRUCE GOLDSTEIN, ESQ., is Executive Director of Farmworker Justice, Washington, DC, a national advocacy organization for migrant farm workers on labor, immigration, and health issues. He received degrees from the Cornell University School of Industrial and Labor Relations (BS, 1977) and the Washington University School of Law (JD, 1980).

Notes

1. U.S. Department of Labor, "National Agricultural Workers Survey 2001–2002," Research report no. 9 (Washington, DC: U.S. Department of Labor, 2005), http://www.doleta.gov/agworker/naws.cfm.

2. U.S. Department of Labor, "National Agricultural Workers Survey," Research report no. 5 (Washington, DC: U.S. Department of Labor, 1994), 2.

3. Department of Labor report.

4. Daniel Rothenberg, *With These Hands: The Hidden World of Migrant Farm Workers Today* (New York: Harcourt Brace, 1998), 324.

5. See Oxfam America, "Like Machines in the Fields: Workers without Rights in American Agriculture," http://www.oxfamamerica.org/pdfs/labor_report_04.pdf (accessed 2004).

6. U.S. Department of Labor, "National Agricultural Workers Survey 2001–2002," 47.

7. U.S. Department of Labor, "National Agricultural Workers Survey," 26.

8. U.S. Department of Labor, "National Agricultural Workers Survey 2001–2002," 5.

9. The NAWS report of 2005, based on 2001–2 data, found 53 percent of field workers are undocumented. D. Carroll, R. M. Samardick, S. Bernard, S. Gabbard, and T. Hernández, "National Agricultural Workers Survey: A Demographic and Employment Profile of United States Farm Workers" (Washington, DC: U.S. Department of Labor, 2005), 5.

10. "Report of the President's Commission on Migratory Labor: Migratory Labor in American Agriculture" (Washington, DC: U.S. Government Printing Office, 1951), 19.

11. Commission on Agricultural Workers, "Report of the Commission on Agricultural Workers" (Washington, DC: U.S. Government Printing Office, 1992), 144, 146, statement of Comm. Michael V. Durando (emphasis added).

12. "Report of the President's Commission," 22.

13. "Report of the President's Commission," 23.

14. Kitty Calavita, *Inside the State: The Bracero Program, Immigration, and the I.N.S.* (New York: Routledge, 1992), 1, 218.

15. Public Law 78, sec. 503.

16. See Ernesto Galarza, *Merchants of Labor* (San Jose, CA: The Rosicrucian Press, 1963); Calavita, *Inside the State*.

17. See, for example, Marie Brenner, "In the Kingdom of Big Sugar," *Vanity Fair*, February 2001, 114, http://www.mariebremmer.com/Documents/KingdomofBigSugar.pdf; Leah Beth Ward, "Desperate Harvest," *Charlotte Observer*, October 31 and November 2, 1999; Alec Wilkinson, *Big Sugar: Seasons in the Cane Fields of Florida* (New York: Alfred A. Knopf, 1989).

18. "Information Concerning Entry of Mexican Agricultural Workers Into The United States" (Washington, DC: U.S. Department of Labor, Bureau of Employment Security, Farm Labor Service, 1962).

19. More information is available at the website of Farm worker Justice, http://www.farm workerjustice.org.

20. *Cong. Rec.* 151 (April 18, 2005): S 3789.

21. *Cong. Rec.* 151 (April 18, 2005): S 3783.

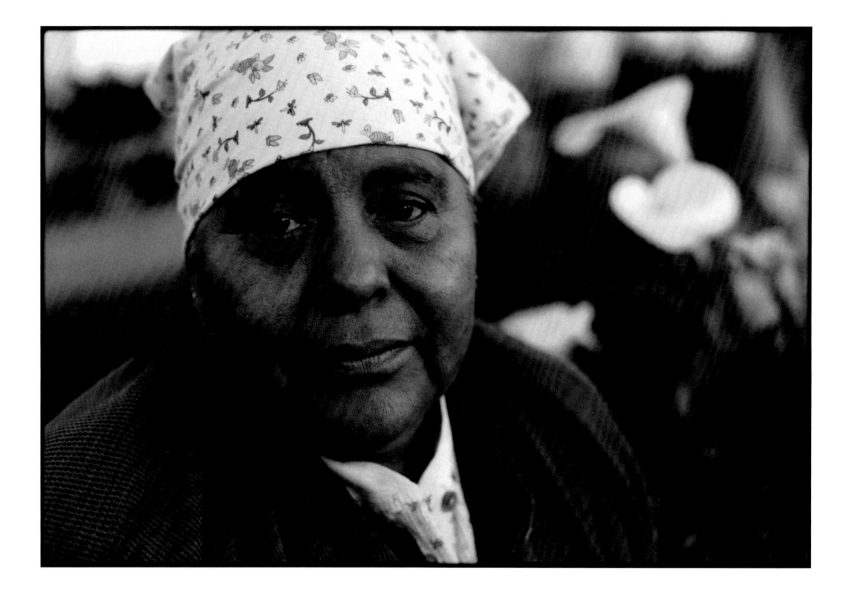

Lucrecia Catalina Camacho Santillán Gómez

An Oral History

Mily Treviño-Sauceda, Oxnard, CA, January 10, 2007

My name is Lucrecia Catalina Camacho Santillán Gómez. I was born on February 3, 1951, in the small town of San Francisco Higos, Oaxaca, Mexico. I was not sure about my birth date until 1987 when I began the process to legalize my status in the United States. I used to go by the name of Hortencia until I found my birth certificate. My mother had eleven children, but only five of us are still alive. I am the second to the youngest child. I only remember that I grew up with my younger sister Rosalina. I did not end up meeting my other two older brothers until several years ago. They had migrated to other states in Mexico (Veracruz and Baja California) looking for a better future for themselves and their families.

I had a tough childhood. I remember my father leaving us when I was only three years old. I do feel I had a sad life, because I always wanted to go to school and learn like other children, but I was not fortunate. I remember that since I was very little, I wanted things, but my wishes did not come true. When I was nine years old, I remember my Aunt Micaela trying to marry me to an older man. My father also sent us a letter telling us to sell everything and move away from his place. When we were kicked out of our home, my cousin, Mario, picked us up and built a small hut for us from palm trees and branches.

Throughout my childhood years, I migrated with my mother and sister Rosalina to other places like Culiacán, Sinaloa, to Hermosillo and Obregón, Sonora, to La Paz, Baja California, Mexico, where we worked picking cotton and tomatoes. In 1963, we migrated to Mexicali and then Tijuana, Baja California. I still remember begging for money there and selling gum at the border to the men and women who crossed to the United States for work. That same year, we migrated back to Oaxaca where I lived with my mother until 1964, when she sold me to an older man for a thousand pesos. This was a common local practice. Later that same year, my sister Rosalina was also sold to an older man, and they crossed the border and went to live in Madera, California.

I always wanted to get married in a white dress, but this dream never came true. I remember having my first child, Josefino, in June 1965, while I was working in the agricultural fields in Oaxaca. When I felt the pain and began walking as fast as I could to try to find help it was too late, and I ended up

delivering my son out in the fields. By the end of 1965, the man I was sold to had left our child and me so I went back to work in the fields to support us. It was hard, but I felt relieved, because this man used to slap me and beat me up without any excuse.

Several years later, I met a man, Félix, whom I agreed to live with. My mother arranged our engagement. It was a different arrangement because I already had a child. He offered food for my mother. We migrated to other states and worked in the fields, harvesting tomatoes. This man and I had two children of our own, Teresa and Félix, in 1968 and 1971, while we lived in Culiacán, Sinaloa, Mexico. He was very abusive towards me and would take my earnings away and use them to go out with other women. He would always push me around and slap me. He finally left my children and me. Later we found he was with another woman.

I was sixteen when a fellow co-worker encouraged me to look for my father, sharing with me that my father had land that I could farm and not have to work for someone else. Until then, I had believed my father was dead. I confronted my mother and soon after that, I received a letter from my father begging me to move in with him since he felt guilty for leaving us.

In 1973, I became pregnant from Raúl, a man from Oaxaca I had met in Culiacán, Sinaloa. Our daughter Lucía was born in December of that year. This man was abusive, and would also slap me and leave me for months. I again decided to look for my father. After finding him, my four children and I moved in with him in 1978. We lived with him for five years in Oaxaca, where I worked in the fields and took care of him until he died in 1983. He was more than seventy years of age.

During the years my children and I lived with my father, I met another man, but we would hide from everyone because he had another family. During this relationship I got pregnant and delivered Eusebia in March 1980. Moreover, in 1981 I became pregnant again, and Alma Delia was born in December of that year. Raúl and I would see each other off and on, but after my father died, we got back together. We had another girl together: María Isabel in 1983. But Raul remained very abusive. Soon I decided to look for my sister Rosalina, but to do so, I had to cross the border in Tijuana to the United States. I left my children under the care of my mother and my oldest daughter Teresa. It was hard to leave them behind, but I needed desperately to look for work to sustain the family. It gives me chills and makes me very nervous to even remember the hardships of how I got to the United States. I can only share that I crossed the border in San Isidro, California and arrived on June 24, 1985, in Oxnard, California. My sister Rosalina was already living there, and I stayed at her place. Two days later, while looking for work, both my sister Rosalina and I were detained and deported by Immigration. We crossed back over the border again to the United States just a week later.

It really upsets me when I think back to those days because I was always nervous and intimidated by the INS (Immigration and Naturalization Service). Since Immigration was tough, it was hard for us to look for and find work. During one crossing to the United States, I brought with me my second-oldest children, Félix and Lucía. We had paisanos in Gilroy, California, and stayed with them in a small trailer where eighteen other people

were also staying. It was during this time that I was raped by one of the other residents, and my next child, Magdelena, was conceived.

In 1986, I remember taking Magdalena, then a newborn, to work. I always wanted to keep Magdalena with me, because I was afraid of being deported and leaving her behind. I would hide Magdalena under the bushes or next to a tree while she slept. Because I could not risk going back to the trailer, my sister and I would hide wherever we could around in the streets or in between the lemon trees. We would wait there until late afternoon, and then to go find something to eat.

It was hard for my family and me to find a job since we did not know the people who hired workers. It took us weeks to find work. There were few places that gave us work, and when they did, it would only be for two or three days a week. Once we were done with that job, we had to try to find another job. Also, since Immigration was tight, we had to wait until late morning (around eleven) to begin our workday. I worked picking bell peppers from August to October.

In November 1986, I left my other children in the care of my mother and eldest daughter, and my twenty-one-year-old son, Josefino, and I migrated to Arizona. There Josefino and I were detained by Immigration and were sent to Nogales, Sonora, Mexico. When we crossed back into California, we worked picking onions and got paid ten dollars cash per day; of that ten dollars, we had to pay three dollars for the ride to work and three dollars for our lunch. We worked from three in the morning until eleven. Sometimes we worked until three in the afternoon, and both my son

and I would then make up to twenty dollars for the day. We were getting paid ten cents per bundle.

I returned to Mexico in 1987 because one of my daughters, María Isabel, who was living in San Francisco Higos, Oaxaca, was very ill. Even though my mother had taken her to a *curandera* (healer) she remained sick. When I arrived, I took her to a doctor, but she did not get better for months.

I did not return to the United States again until 1988. I returned to file and legalize my status since amnesty was still in effect, but I had to borrow five hundred dollars to pay for the paper work. First, I submitted the application for my son Félix, since the INS abused him badly (often when he was picked up by their officers he would be punched and kicked). I then submitted the application for my daughter Lucía and finally, for myself.

I then met a man, Gorgonio, and I fell in love for the first time in my life. We tried living together for some time. I got pregnant, and Daisy was born in 1988, but Gorgonio's mother was never happy about our relationship, so she convinced him to leave my children and me.

I returned to Mexico and after a while, I immigrated back to the United States with the remainder of my children (Josefino, Félix, and Lucía were already living in California). I worked in Oxnard, Gilroy, and Morgan Hills, California, and in Glendale, Arizona. I worked picking strawberries, cherry tomatoes, bell peppers and California chiles, nuts, cherries and plums. I also worked harvesting onions and garlic and in the planting of strawberries. I traveled back to Gilroy, where I worked picking bell peppers on a seasonal basis. During the summer months, while my younger

children were off school, I would take them to work harvesting peppers with my older children and me.

I remember taking my youngest daughter, Lucrecia, to work. (She was born in 1993, to myself and another man, Abelardo, whom I had met in 1991.) I had no money to pay someone to take care of my children while we worked. When she would fall asleep, just as I had done with Magdalena, I had to hide her under a tree or bush, or even in the back seat of the car that belonged to a co-worker who would transport us to work.

My older son Josefino married and stayed behind in Oxnard, California. He would transport us to Gilroy. My son Félix also helped me out up until 1988 when he started his own family. I decided to stop traveling to Gilroy in 1997 because my children were older and did not want to migrate anymore.

I then began taking my children back to Oaxaca, Mexico, to continue with an old traditional belief, which is to prepare the festivities that we call Fiesta de Mayordomía. This is an indigenous tradition, a festival about celebrating with food, dances, and music all day. We make this trip every three years and have to be there a month before the date of the festivities to prepare all the details for this townwide celebration. We are in charge of finding the musical group, the singers, the people who will prepare the fireworks, and the person who will carry the famous bull, which is a man-made suit with fireworks. The festivities begin in October with the celebration of the patron saint of the town, San Francisco de Asís, and they continue up to December. It takes us a full year to raise the money for these festivities that can cost anywhere from three up to ten thousand dollars.

In 2002, a friend named Gaby Martínez introduced me to Líderes Campesinas. I became very interested since the group speaks about domestic violence, which I had been a victim of. Through them, I have also learned about pesticides, worker rights, and about the rights as a home renter. When I began working with the group, I became aware that I had been abused when not paid minimum wage and when I was sprayed by pesticides and that my labor and human rights had been violated as well. Since I am a single mother, I was always afraid of speaking my mind. I was afraid that my employer would call Immigration, but now I am not afraid because I have learned about my rights.

I have learned I have worth, that I am very valuable as a person and as a woman. I love attending my group's trainings and conferences. It was here that I learned many things that I did not know before about the rights we have as women and as workers. I always talk with my paisanos about Líderes and have referred many of my co-workers, relatives, and neighbors to get information regarding domestic violence and work-related rights.

During this same year, 2002, I left for Oaxaca, Mexico, to visit my mother, Magdalena, who was very ill. She died at the age of ninety-seven, in 2004. I learned from my mother to never give up. Even though I did not enjoy the same life other children I knew had, I have been able not only to survive hard times, but also to build a beautiful family, which is now united and loves and respects me.

In 2006, I again began the application process for my U.S. citizenship. I am taking citizenship classes at an adult school, and once I become a citizen I want to travel to either Washington or

Oregon state. I feel like a millionaire since I now own a big house that we were able to buy as a family and where all my children have space and are welcome. Even though all my children have grown and started their own families, all except one live in our communal home. There are six units where each of my children and their families live. We all contribute to the mortgage and utilities. I am still working in the fields several months during the year, still hustling for a job.

Mily Treviño-Sauceda is the founder and executive director of Líderes Campesinas. The original interview with Sra. Lucrecia was transcribed in Spanish by Silvia Berrones-Treviño. The interview was arranged and videotaped by Ramona Félix. Assistance in English translation and editing were provided by Carla Treviño, Suguet López, and Mily Treviño-Sauceda.

The kitchen wall inside the home of a farm worker, Biola

Acknowledgments

There has not been a day since I began this project that I have not been affected by it. The Migrant Project submerged me in a world that up until March 2002 I had only wondered about from afar, but that I now realize I am, and am proud to say, will always be a part of.

I offer my deepest appreciation to the many dozens of people who greeted my prying lens with openness, when they just as easily could have simply turned away. In many more instances than not, I was warmly welcomed and invited into homes, fields, camps, offices, and farms. Children gathered around and assisted me, and even those people who chose not to be photographed, declined gracefully, offering their best wishes.

Though I did all the traveling, coordinating, research, shooting, and printing of the work that became the traveling exhibition, the creation of this book was another thing entirely. Neither of these undertakings could have ever been realized without the help of numerous individuals and organizations who generously embraced the idea from its inception to its final publication. Generous support came in the form of knowledge, patience, contacts, trust, advice, love, funds, and spirit.

To the book's contributors: Dolores, Anna, Lucrecia, Mily, Bruce, José, Kurt, and Alberto, all took time out of their busy lives not just to contribute but to inspire me with their commitment, activism, generosity, heart, and friendship.

The project's original sponsors: The Center for Latino Policy Research at the University of California, Berkeley, California Rural Legal Assistance, Inc., the Kurz Family Foundation, and G.L.E.A.N. bought into the vision of the project before I even knew exactly what it might be, and I am indebted to them for that.

There are no words to thank my parents, who first put a camera in my hands and encouraged me to see. They continue to encourage me every day, and I am lucky to have had them there beside me. I owe a great deal to Susan R. Clark and the Columbia Foundation for understanding what we hoped to accomplish with this book from our first conversation, and for their generous underwriting of its publication.

Lisa Pacheco, my editor, supplied enthusiasm, energy, and, most important, an unwavering dedication to set out on this adventure with me from day one. Her support and guidance along the way allowed this book to become exactly what I had envisioned it to be. Dr. María Kelly was instrumental in not just coordinating the engagement at the University of New Mexico and the National Hispanic Cultural Center, which initially got the ball rolling for this book, but also first introduced Lisa and me. Thanks to the book's

designer, Mina Yamashita, for her hard work and the fresh perspective and elegant eye she brought to the project, and to Meredith D. Dodge, whose work copyediting the manuscript made me look a lot smarter than I am.

Meredith Flores provided countless proofreads, diligent researching, footnoting, fact checking of the initial and final manuscripts, as well as a tireless attitude every step of the way. Stacy Caldwell became a friend during the birthing process and was there at every turn. Tim Knight and Barbara Osborn read portions of *The Migrant Project* from exhibit text at the exhibit's inception to this book's final manuscript, offering incisive and invaluable critiques, and just as important, celebratory friendship along the last several years. Prof. Bob Barsky at Vanderbilt University initially urged me to publish this work, kicking me into gear on what would be a search for the right publisher lasting more than two years.

I am also grateful for the new friends who inspired, raised funds, and networked in the name of getting this work seen around California and the rest of the country: Rosalind Eannarino, J. J. Rosenbaum, Stephen Gleissner, Cynthia Adcock, Charles Steiner, Catherine King, Dennis J. Bixler-Márquez, PhD, Ginny Brush, Virginia Clarke-Laskin, Eric Cárdenas, Claudia Luján, Diahnna Núñez, Enrique Medina Ochoa, Barbara Clinton, Carmen Durazo, Sandra Tauler, John Kennedy, Mary Catherine Ferguson, Deborah Gangwer, Michael Gary, Sonia Giordani and Tim Johnson, Kate Somers, Ellen Gorelick, Geoff Green, Alicia Huerta, William Kohl, Amanda Meeker, Roger Rosenthal, Rep. Loretta Sanchez,

Rep. Hilda Solis, Rep. Luis V. Gutierrez, Jennice Fuentes, Scott Shafer, Ellen Widess, Prof. Stacey Rucas, David Damian Figueroa, and especially Rosa Lucas.

The following organizations and individuals provided essential important help along the way: the staff of Farmworker Justice in Washington, DC, Diane Upson, Candace Chatman and Kodak, the incredible women of Líderes Campesinas, California Council for the Humanities, KCET and *Life & Times*, Craig Kovacs and the staff of First Professional Photo Center, Don Weinstein and the staff of Photo Impact, and Bonny Taylor and The Icon.

I owe special gratitude to Alberto and Digna Montrealegre and the crew at DNG Enterprises for their ongoing work in keeping up the exhibit's traveling prints as well as my spirits; the entire staff and board of trustees of the Fullerton Museum Center for taking a chance on me twice when they had no reason to do so once; Dan Alba and the staff of Facing History & Ourselves; and Scott McKiernan and the staff of Zuma Press.

My thanks to those who contributed updated statistics for the book: Josh Sheperd from the National Center for Farmworker Health; Don Villarejo, PhD, Ron Strochlic of California Institute for Rural Studies, Adrian Woodforki of the California Department of Food and Agriculture, Heather Hafleigh, Marc Grossman of the United Farm Workers, Marc Cooper, Claudia Smith, Kat Rodriguez, and Doug Flohr of the USDA.

And thanks to individuals who were there at the inception or offered always-appreciated support along the journey: Andy Furillo,

Alan and Traci Nahmias, Antonio Flores, Arianna Huffington, Caprice Young, Carolyn Cole, Cecila Barros, Dan Strehl, Dean Larson, Dr. Juan-Vincente Palerm, Emanuel Benitez, Ephraim Camacho, Eric Schlosser, Felicia Kelley, Gay Hill, Graciela Martinez, Haydee A. Diaz, Claire Rasé, Hector Hernandez, Irma Avila, Jamie Welling, James Quay, Jeff Ponting, Jesus López, Jim Hubbard, Joceyln Sherman, Joe Felz, John Karwin, Julia Dean, Julie Levak, Kim Stuart, Leonard Kurz, Linda Burstyn, Lorena Domínguez, Lucy Pollak, Luis Magana, Lupe Quintero, Marisol Ayala, Mark Schact, Marta Kochenower, Mary Jacka, Mary Milelzcik, Michele Lipkin, Mike Smith, Nathalie Bertat, Phil Bruce, Ralph Lewin, Santos Gomez, Suzanne Lettrick, Sylvia Partida, Tavin Marin Titus, Teresa Figueroa, Torie Osborn, and Travis DuBry.

Finally, to my partner, Steve, whose critical eye, open heart, unflagging belief in me and my work, and twisted sense of humor have kept me afloat and proven more than good reason to come home. Thank you for everything.

❧

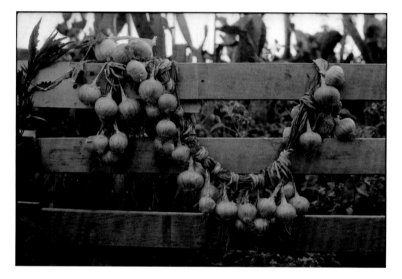

A garden inside a migrant camp, Soledad